IMAGES
of America

SOUTHBRIDGE

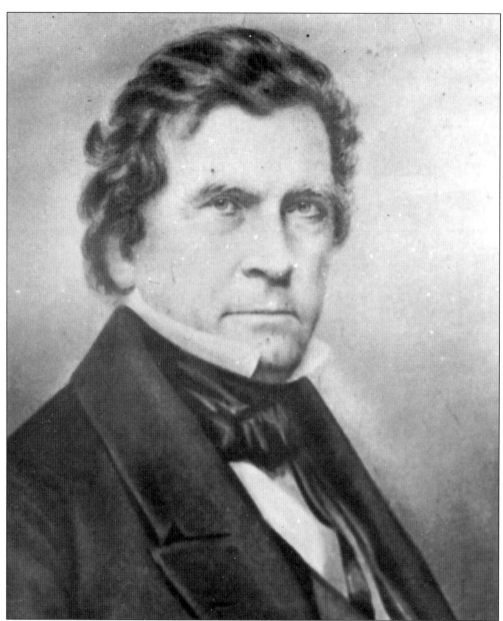

William Learned Marcy, shown here, is arguably the most notable native of Southbridge. He was born in 1786 at the Moses Marcy (his grandfather) home, which was located where the Notre Dame Roman Catholic Church is today, and died in 1857. He studied law at Brown University and led American troops to their first victory in the War of 1812. He was treasurer (comptroller) of the state of New York during the construction of the Erie Canal and served as senator, governor, and state Supreme Court judge for the state of New York during his political career. He was secretary of war under Pres. James Polk during the Mexican War and served as secretary of state under Pres. Franklin Pierce. His most famous quote was made during a debate where he backed Pres. Andrew Jackson's right to make political appointments and stated, "To the victor belong the spoils!" The highest point in the state of New York is named after Marcy: Mount Marcy.

IMAGES
of America

SOUTHBRIDGE

Southbridge Historical Society
John Moore and Steven Brady

ARCADIA

First printed in 2001.

Published by Arcadia Publishing,
an imprint of Tempus Publishing, Inc.
2A Cumberland Street
Charleston, SC 29401

Printed in Great Britain.

Library of Congress Catalog Card Number: Applied for.

For all general information contact Arcadia Publishing at:
Telephone 843-853-2070
Fax 843-853-0044
E-Mail sales@arcadiapublishing.com

For customer service and orders:
Toll-Free 1-888-313-2665

Visit us on the internet at http://www.arcadiapublishing.com

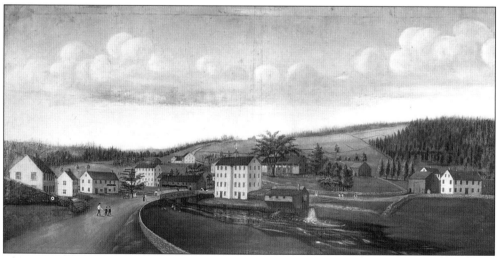

This is a painting of Globe Village by Francis Alexander. This landscape was painted in 1822 and shows Globe Village in a view looking west on what is Main Street today toward Sturbridge. The four-story mill building to the right of the bridge was part of the Globe Manufacturing Company, from which Globe Village derives its name, and is seen in photographs in this book when it served as the carpenter shop for the Hamilton Woolen Company (see page 39).

CONTENTS

ACKNOWLEDGMENTS

We wish to express our gratitude to the many people and organizations that supported this project. Thanks go to Ruth Urell, library director, and the Jacob Edwards Memorial Library, for sharing its collection with the Southbridge Historical Society. Also, for the loan of photographs and images, thanks go to Armand, Jeanne, and Don Brault; Mary Gendreau; Spiro and Debbie Thomo, St. Michael's Church; Roy Wilson of Flood's; Niove Billis and Helen Pantos, St. George's Church; George and Jennie Vasil, St. Nicholas Church; Doris Hopkins; Raymond Lenti; Richard Harwood; Robert Beck; Raymond Petrelli; Kathryn Peters; and Ernest Tsoules. Their willingness to share helped us round out this book.

Also, many others provided information about a number of the images, especially by identifying people and places. They are Francis and Yvonne Splaine, Jean Earnest, Nancy Normandin, Norman Cloutier, Wayne and Eleanor Morse, Frank DiBonaventura, Richard Whitney, Eva Salviuolo, Raymond Bombardier, Robert Berry, Maria Dirlam, Ann Tanionos, Helen Vespucci, Richmond Clemence, Francis Bousquet, and Charlene and Matthew Brady. We are grateful for their enthusiasm.

Other sources of information used for this book were *Southbridge* (1889), by Levi B. Chase; the Quinebaug Historical Society leaflets; and the *Sesquicentennial Album* (1966), by Arthur Kavanaugh, Evelyn Petrelli, and Mary Anna Tien. We regret if anyone's name has not been included here.

Finally, special thanks go to Southbridge Photo Lab, 176 Main Street, for donating reproduction services; Maureen Prokos, who donated the 1946 clambake picture to the Southbridge Historical Society; and Margaret Morrissey and Evelyn Petrelli, librarians, whose knowledge of both the library's and the Southbridge Historical Society's collections—and technical support—was invaluable.

Authors' note: We realize that there are many industrial concerns in the town of Southbridge today with long and distinguished histories. It is our intention to illustrate the primary industries of the town at the beginning of the 20th century, and, of course, the oldest company in town—the Russell Harrington Cutlery Company. Some other prominent industries include Hyde Tools, founded by I.P. Hyde in 1875; the United Lens Company, founded in 1916 by Fileno DiGregorio; the J.I. Morris Company, founded by J. Irwin Morris and John C. Dirlam in 1920; and the A & M Tool and Die Company, founded by the Simonelli brothers in 1948.

INTRODUCTION

The story of how Southbridge came to be is fascinating. In 1683, the founders of the town of Oxford were awarded a King's (land) Grant from the Crown. The western boundary began at a point on Lebanon Hill and ran northerly from the Connecticut border through the sites of the Southbridge Town Hall, Whitford Block, the flatiron building on Hamilton Street, and the airport. In 1732, the southern end of this great tract was set off from Oxford and incorporated as Dudley. Land north of this section was set off for the incorporation of Charlton in 1755.

Meanwhile, 42 petitioners applied for land grants between "Oxford, Brimfield, Brookfield and the Province Line" in 1729. When the Massachusetts General Court granted this request, an association of proprietors was formed. One of these was James Deneson of Medfield, Massachusetts. In July 1730, the properties held a drawing to award lots. Young and intrepid Deneson set out into the western frontier. He arrived in this lonely wilderness in the fall of that year, found a rock shelter on one of his lots, and settled on that slope just south of the river. This would become Sturbridge.

Not long after, another settler arrived—Moses Marcy. By 1732, Marcy was operating a sawmill on the Sturbridge-Oxford line (near today's Central Street bridge). Later, blacksmith Samuel Freeman bought some land from Marcy, and one lot became the site of Freeman's Tavern on Elm Street.

Others had been arriving, including William McKinstry (in today's Pleasant Street neighborhood); William and John Plimpton, who owned the Globe and Westville sections, respectively; Col. Thomas Cheney and John Vinton, who owned land east of Marcy's, downstream along the river to Sandersdale; and John Savin, who settled on the north side of the river.

By 1790, the settlements had been growing continuously. In that year, John Gray began the first textile business when he began wool carding, dyeing, napping, filling, and dressing, just upstream from Marcy's Mills.

In 1791, Oliver Plimpton, Esq., and Major Ellis were operating a store. Zebina Abbott opened a variety store in Centre Village in 1799.

Records show that inhabitants of the area had served in the French and Indian and Revolutionary Wars.

In a report about why this was such a desirable area for settlement, written by Joshua Harding in 1796, he stated in part that "the Quinebaug River, which falls so nearly central through, with its excellent seats for mills and other waterworks, are circumstances highly favorable to the

introduction of useful mechanics, and rendering it a place of activity and business. The goodness of the soil, with excellent forests abounding with all kinds of timber for building, are estimates of great value to the general plan." The rush was on, yet one important thing was missing. To attend religious services, Sturbridge residents had to walk through the forest five to six miles, including crossing the river on a log. Dudley and Charlton residents had even farther to travel. In 1795, a committee met at Freeman's Tavern to consider the formation of a poll parish or town made up of parts of the three towns.

Between 1796 and 1800, Sturbridge, Charlton, and Dudley had been petitioned a number of times and refused this request. Finally, in 1800, after application to the Massachusetts General Court, permission to incorporate as a parish was granted.

In the meantime, a meetinghouse committee had been formed. They raised enough money to raise a building on July 4, 1797. It was finished in early 1800, with loose board benches for pews. During the next 16 years, it served the Baptists, Congregationalists, Methodists, and Universalists of the poll parish. On April 13, 1801, Jedediah Marcy deeded the land on which the building sat to its proprietors, and Benjamin Freeman gave a parcel to be used as a burial ground (Oak Ridge Cemetery). Some Plimptons, Jeremiah Shumway, Lt. Robert Edwards, and at least five children were interred that first year.

In 1810, as tensions between the United States and Great Britain increased, "the parish organized an artillery company ready to meet any hostile fleet that might sail up the Quinebaug." By late 1811, residents in the parish favored the formation of a town. In June 1814, a petition to the Commonwealth of Massachusetts was rejected. On October 10, 1815, the parish received a favorable response, and, on January 31, 1816, at a parish meeting, it was voted "to accept the territory given to us by the last court's committee for a town by the name of Southbridge."

The Act of Incorporation had been drafted at a meeting on December 6, 1814, and a committee was formed then and there to consider proposed names, including Southbridge and Quinebaug. Southbridge was chosen. Moses Plimpton said, "Southbridge was the name proposed by the venerable Captain Abel Mason, Sen." On January 1, 1815, the name Vienna was proposed, but, again, Southbridge was selected.

The town was officially incorporated on February 15, 1816.

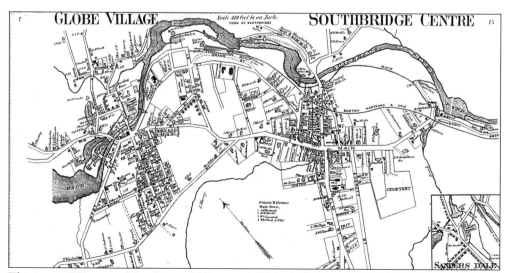

This is an 1873 map of the Centre Village and Globe Village sections of Southbridge.

One

EARLY IMAGES
AND BUSINESSES
AROUND TOWN

This 1826 map shows a section of the
Centre Village of Southbridge, which is in
the area of the intersection of Main, Elm,
and (what would become) Central Streets.
The five buildings on the left (slanting
down on an angle) are on the north side of
Main Street between Hamilton and Central
Streets. The fifth building from the left
(300–308 Main Street) is the only building
still existing today at its original location.
The two buildings on the upper right are
Healy's Tavern and L. Ammidown's store
on Main Street. The buildings on the lower
half of the map are, from left to right, an
oyster shop and the Ammidown Hotel
(constructed by Holmes and Luther
Ammidown in 1824–1825). In the lower
right-hand corner is the Columbian
building, which was built in 1814 and
owned by Ebenezer Ammidown in 1826.
Between the Ammidown Hotel and the
Columbian building is Elm Street.

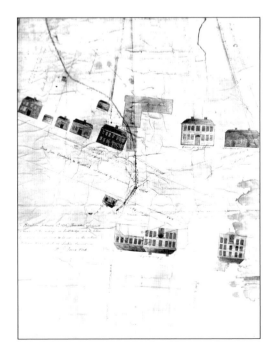

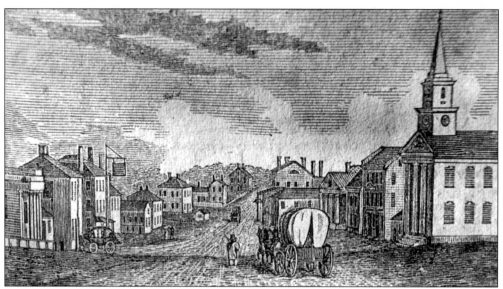

This woodcut from c. 1836 shows Main Street in a view looking west. The church on the right is the Central Baptist Church.

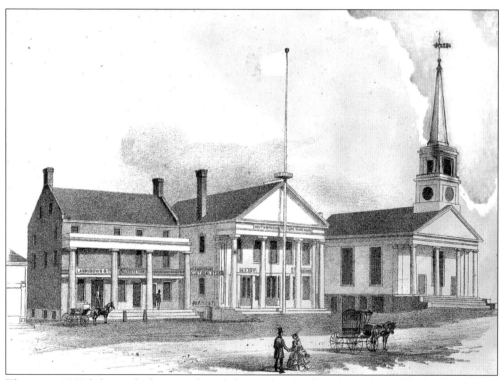

This is an 1862 lithograph showing, from left to right, the first Ammidown Block, the original town meetinghouse, and the Central Baptist Church.

This 1860 photograph shows the first commercial district in Southbridge, located on Main Street between what is now Central Street and Foster Street. On the left is Healy's Tavern, built c. 1810. Next to Healy's Tavern, on the right, is the first Ammidown Block, constructed c. 1828. The original town meetinghouse, built in 1797–1800, is the next building on the right. Finally, we see the Baptist church, which was built in 1848. All of these buildings were destroyed in a fire that started at 1:30 a.m. on November 14, 1863.

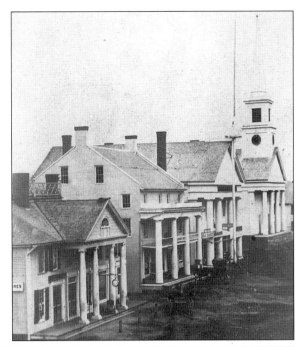

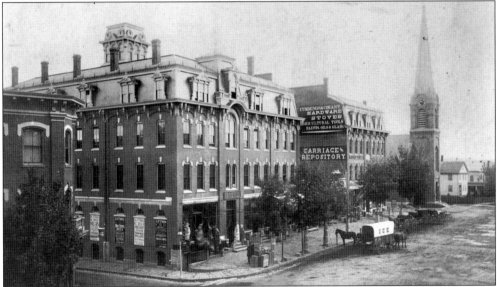

This is an 1880s view of the buildings that replaced the structures destroyed in the fire of November 14, 1863. On the left is the four-story C.A. Dresser House, built as a hotel in 1870–1871 on the site of Healy's Tavern. The four-story building to the right of the C.A. Dresser House is the Ammidown building, built by Holmes Ammidown in 1870–1871 on the site of the original town meetinghouse. Ammidown had the second story of this building specially built to house a "modern" library, which he donated to the town. It served as the town's library from 1872 to 1915. Between the C.A. Dresser House and the Ammidown building, but hidden behind trees, is the one-story Boston Branch Store, built c. 1872 on the site of the first Ammidown Block. On the right side of the picture is the Central Baptist Church, constructed in 1864–1866.

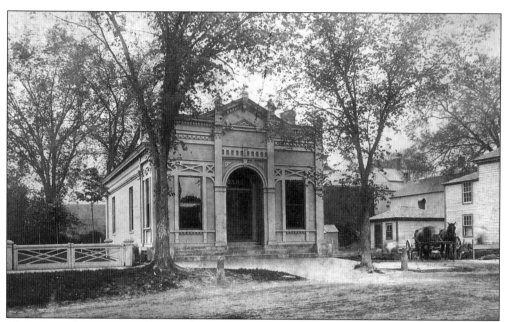

This 1880s photograph shows the Southbridge Bank, which was founded in 1836. This building was located on the site of the current Southbridge Savings Bank.

This is a view of the Southbridge Savings Bank on Main Street in August 1891. This building was built in 1887. Although the building still exists, it bears little resemblance to the structure in this photograph.

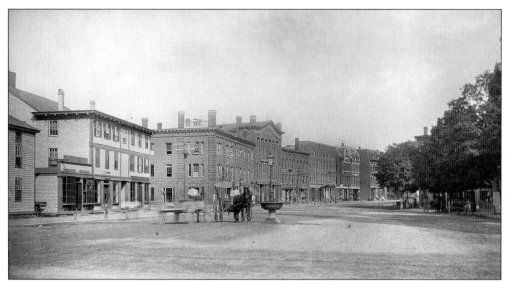

This *c.* 1885 downtown Southbridge view is looking west on Main Street. From the left are a small storefront, the Columbian block, and the Edwards House (a hotel built by William Edwards in 1859 and later called the Blanchard block). Next are the Edwards Block, built by John Edwards (brother of William) in 1860, and a building constructed in 1853 by William Edwards. Sylvester Dresser constructed the next building in 1875, the Dresser House. To the right of the Dresser House is the "S.K. Edwards," built by S.K. Edwards in 1878 and followed on the right by the Memorial Building, built in 1882 by the S.K. Edwards Hall Company. The last building on the right facing the camera is the Barnes building, built in 1871. All the buildings in this photograph remain in use today with the exception of the small storefront.

The Columbian building is shown here at the corner of Main and Elm Streets. This building was constructed in 1814 and was moved to the corner of Foster Street and Wardwell Court in the early 1890s in order to make room for the YMCA that was constructed in 1893.

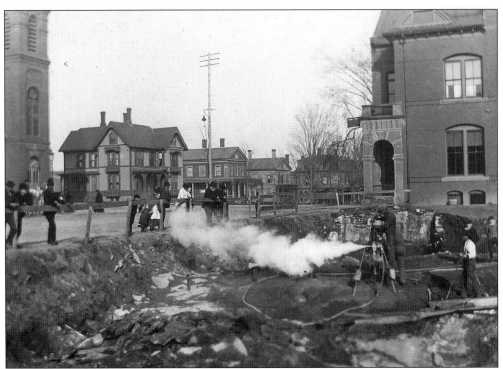

Construction of the YMCA was begun in the early 1890s with the necessary removal of ledge before the foundation could be laid. In the background is the Central Baptist Church, homes where the library is today, and the Southbridge Savings Bank building.

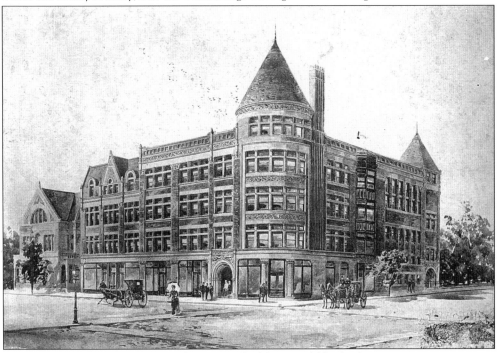

This is an 1890 rendering of how the YMCA building would look after construction.

Four boys watch the YMCA site work from the top of the ledge behind the Lenti building. The barns on right were part of the Tiffany home—now the Southbridge Evening News. At the upper left is the rear corner of the Southbridge Savings Bank.

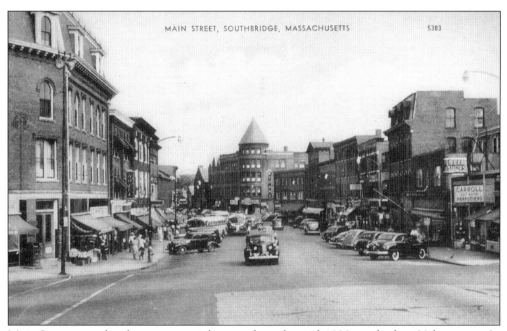

Main Street was a bustling commercial center from the mid-1800s to the late 20th century. In this busy 1940s postcard view, three buses can be seen on the left, midblock. The YMCA building, in the center, was about 50 years old in this scene.

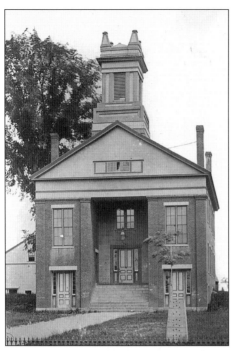

The 1838 town hall building, located at the site of the current town hall on Elm Street, is shown here as it appeared in the 1870s. This building was replaced by the current town hall in 1888.

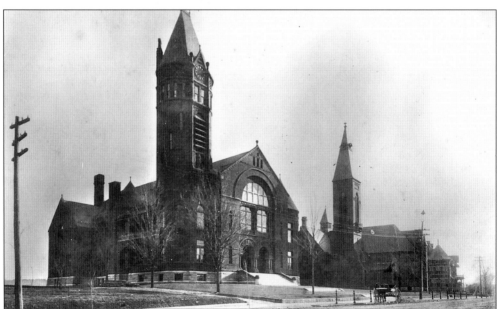

This is an 1890 view of the 1888 town hall and the Elm Street Congregational Church. The town hall building is the third and current meetinghouse used by the town (see pages 10 and 11 for images of the first meetinghouse). The clock face seen in the tower of the town hall has never been used as a clock; it is only decorative. The town clock is located in the steeple of the Baptist church on Main Street (see page 82). The Congregational church building dates from 1885. It was constructed on the site of the 1821 Congregational church. The old church was replaced after it was heavily damaged in a windstorm in the early 1880s. The steeple of the Congregational church pictured above was destroyed during the Hurricane of 1938 (see page 83).

The lovely little Central Street Firehouse stood where the municipal parking lot is now, until the 1960s. The left side of the building housed the Southbridge Police Department headquarters at the time of this scene. The lower tower held the fire bell, and the tall tower was for drying hoses.

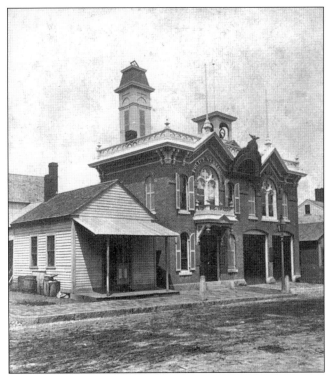

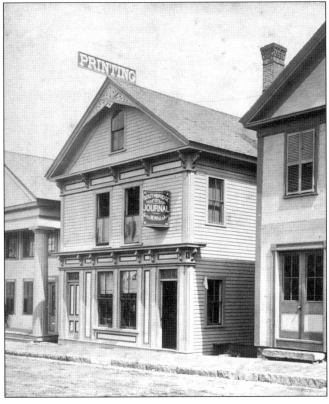

Southbridge had a number of newspapers over the years. The *Reformer and Moralist* began publishing in 1828, the *Moralist and General Intelligencer* and *Southbridge Register* in 1829, the *Ladies Mirror* in 1830, and the *Village Courier* in 1832–1833. At one time, there were two or three in competition. One was the *Southbridge Journal* on Central Street, which published between 1861 and 1900. The *Southbridge Press* published from 1853 to 1940. The *Southbridge Herald* published from 1902 to 1929, and the *Southbridge News* began publishing on August 27, 1923. Over the years, that paper was also called the *Southbridge Evening News* and the *News*. It is still being published today.

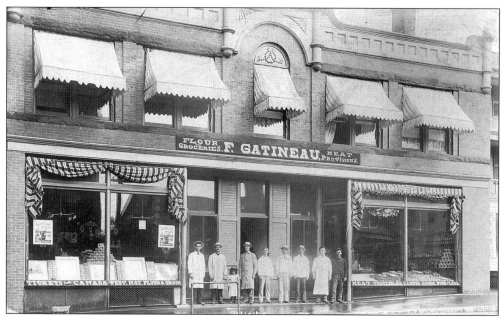

In this photograph, taken before 1910, are the employees at Felix Gatineau's store. The building, 7–11 Elm Street, was known as the YMCA annex back then. From left to right are Joseph Dufault, Mr. Arpin, a little girl, Felix himself, Mr. Carmel, and four unidentified men. Each window had a double gaslight fixture. One could purchase travel tickets for Canada and West, hay, grain, groceries, and meats. Later, this was the location of Serleto's Market and David Lenti's Shoe Store.

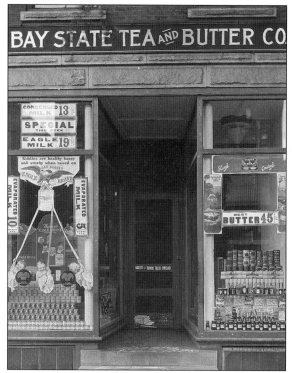

This view shows a storefront window dressing in the early 1900s. This is the Bay State Tea and Butter Company, located in the Barnes Block on Main Street.

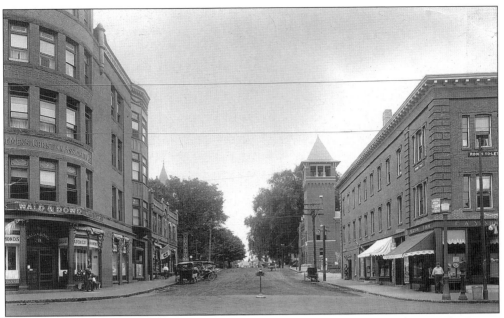

The photographer stood in the center of Main Street to capture this *c.* 1915 view up Elm Street. At left is the YMCA building and the Wald & Dowd jeweler's shop. Up the street at 7 Elm is Serleto's Market, flying the Italian flag. Later, 7–11 Elm Street would come to be known as the Lenti building. Just beyond, the vertical sign that reads "Vulcanizing" marks the location of Centre Service Station. On the right is the 1859 Blanchard Block, home of Blanchard's Theatre. Farther up is the 1899 Southbridge Fire Station.

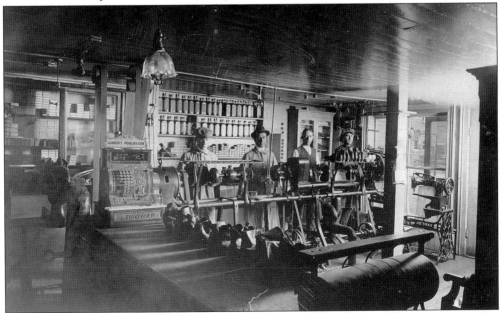

Probably taken *c.* 1917 or 1918, this is an interior photograph of Lenti's Shoe Repair Shop. The location was a wood-frame building at what is now 15 Elm Street. David Lenti is second from the left. During these years, he employed a number of Italian immigrants to help them get established in America.

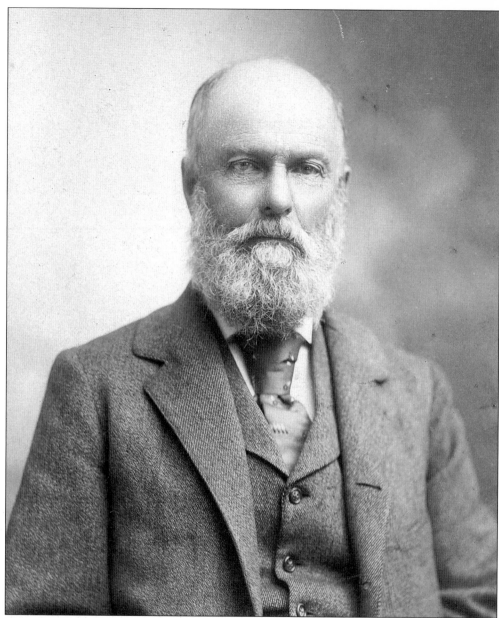

This distinguished-looking gentleman is Charles Weld, founder of Weld & Beck Grain Company. He arrived in Southbridge in 1850 and went to work for James Gleason at the gristmill, lumbermill, and pail factory on West Street. They later became partners and enlarged the business to River Street. In 1854, Weld & Gleason began a grain business in West Dudley. That company relocated to Foster Street as Weld and Prindle. Some time after this, Weld became partners with John Beck. Weld died on June 21, 1912. According to his obituary in the *Southbridge Press*, published on June 28, 1912, he helped establish the region's first telephone line in 1879. He had a "brilliant wit that made him so well known and quoted throughout the region. When agents of the Grand Trunk (railroad) called on him a few days before the end (his death) regarding the purchase of a right of way through his property, he observed with twinkling eye that no man could escape railroads and death."

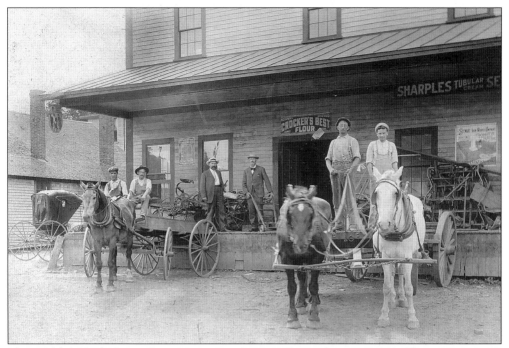

The Weld & Beck Grain Company is seen here on Foster Street *c.* 1903. These two wagons look ready to go. Third from left is John Beck, one of the partners. On the far right is Charles Beck, father of Robert Beck. Robert Beck was the last family member to run the business. He retired in 1984.

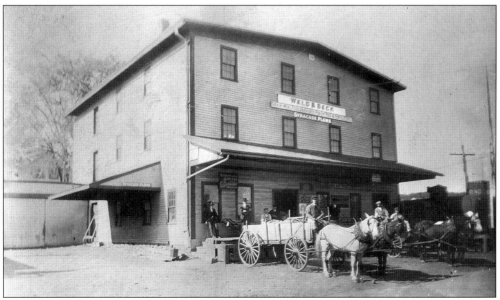

This is another view of Weld & Beck, also *c.* 1903. The small roof on the left was a carriage port. Inside the low ell, on left, was a carousel-type setup that was turned by a horse and connected to a series of belts and pulleys, which operated the three-story freight elevator. Dick's Hardware Store sits on the site of the ell. The company is still open under new owners, but still called Beck Grain Company.

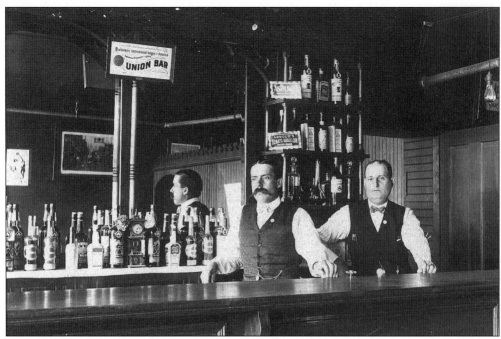

Bebo's Saloon on Central Street was a popular gathering place. This photograph was taken probably *c*. 1900. Owner Joe Bibeau sports a handlebar mustache. He and his barman wear bow ties and vests.

Another Central Street establishment was the Nipmuc House, a local landmark and watering hole for much of the 20th century. On the front steps, in this *c*. 1920 image, are John Beck, of Weld & Beck, who spoke seven languages, and proprietor Joseph "Spike" LaRiviere.

This view of Main Street looking east was taken *c.* 1907. To the left we see the "new" Baptist church that was constructed in 1864–1866 after the fire of 1863. To the right of the church is the current site of the Jacob Edwards Memorial Library.

This 1881 photograph shows Langevin's Millinery Shop, located in the flatiron building on Hamilton Street.

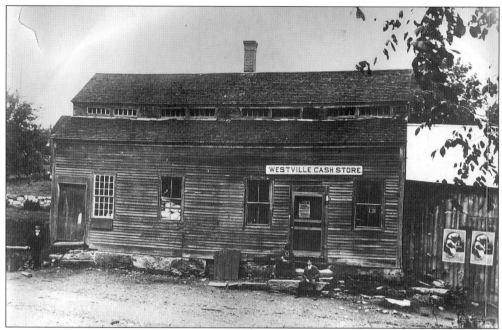

The Westville Cash Store is seen here as it appeared in 1890. Although this building was actually located on the Sturbridge side of the Quinebaug River, it is included in this book because Westville (Sturbridge) and Shuttleville (Southbridge) felt like one neighborhood to the residents. The building burned to the ground in 1900.

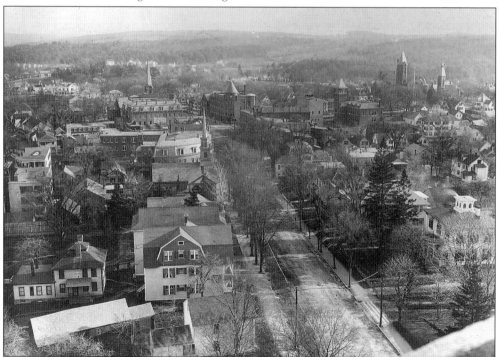

Main Street is viewed here from the tower of the Notre Dame Roman Catholic Church in 1915. The impressive house with cupola at the lower right is the current site of CVS.

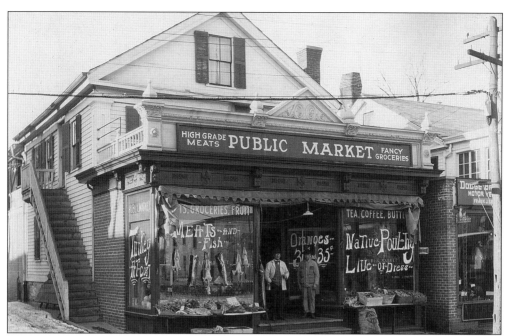

This photograph shows the Public Market at 55 Central Street *c.* 1920. The very lean-looking fowl seem to be hanging on the outside of the store window. This store later became Salviuolo's Southbridge Wholesale Grocery, specializing in fruit and vegetables. In 1960, the store became Gil's Market. Today, it is the site of Central Pizza. The two men are unidentified. To the right is Frank J. Serleto's Dodge Dealership.

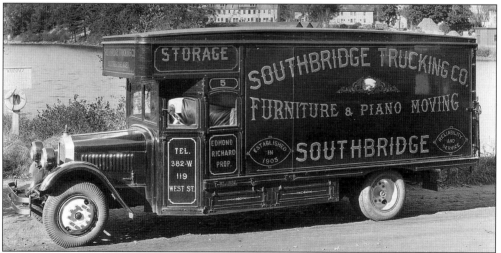

Southbridge Trucking Company's first truck (No. 5) is seen here on West Street in October 1928. Vehicles one through four were horse drawn, originally licensed in 1905 to move textile manufacturing machinery, raw materials, and unfinished textile goods. By 1928, owner Edmond Richard was also moving households. In the late 1940s, Noe "Shine" Frenier bought the company and owned it until *c.* 1961, when it was sold to Norman Benoit. In 1970, Norman Cloutier became the owner until 1985, when it was sold again. The business name was changed to Industrial Transfer—worldwide industrial movers. In the background is Hamilton Woolen Company's "Big Pond."

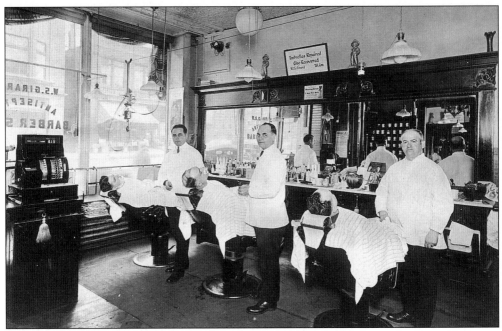

Girard's Barber Shop was in business for more than 40 years on Elm Street. In this *c.* 1930 view are, from left to right, barbers Arnold Girard, Walter Girard, and Mr. Beaudry with unidentified customers in the chairs. Reflected in the mirror are some of the individual customers' shaving mugs. Part of the YMCA and Lenti buildings can be seen through the window. You could also have your umbrella repaired.

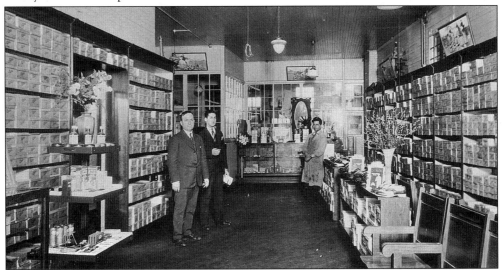

By 1929, the approximate date of this photograph, Lenti's Shoe Store was located at 11 Elm Street, where it was in business until June 1982. By the early 1950s, Lenti was semiretired and son Raymond Lenti took the helm, along with his brother David J. Lenti. Shown here, from left to right, are David Lenti, George Mathieu, and Leonardo DiGerolamo. Mathieu later opened his own shoe store across the street, at 22 Elm, in 1937. Mathieu's later relocated to 334 Main Street and remained in business until 1987. The chairs were made by Dani and Soldani Woodworking, still in business on Worcester Street.

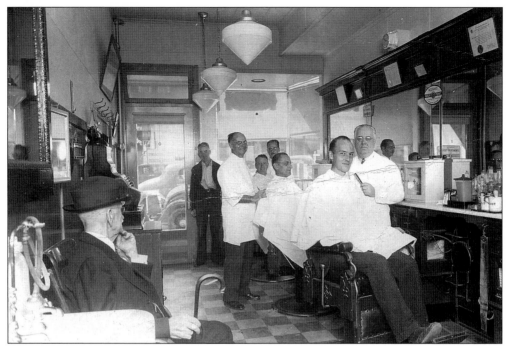

By the late 1930s, Girard's Barber Shop had moved a little farther up Elm Street. Waiting for his turn in the chair is Mr. Adams, with cane. The barbers are Walter Girard, on left; Arnold Girard, center background; and Dennis Carey, on right, with Edward Butler in the chair. Arnold continued to cut hair here into the early 1970s.

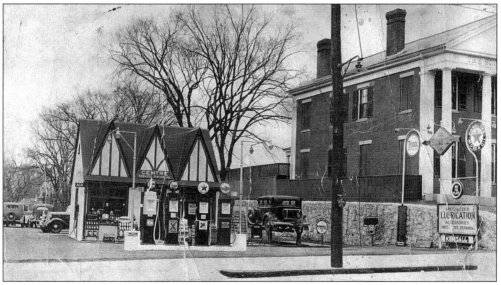

Pictured in 1932 is the Centre Service Station on Elm Street. Note the open-air lift to the right and four different brands of gasoline. Harry Madson operated the business from 1945 to 1955, at which time he sold it to Ray Bombardier, who enlarged and ran it here until the mid-1970s. Prior to Madson, when the photograph was taken, the station was owned by a Polish man or Irishman, according to Bombardier. On the right is the *Southbridge Evening News* building, originally the home of Bela Tiffany.

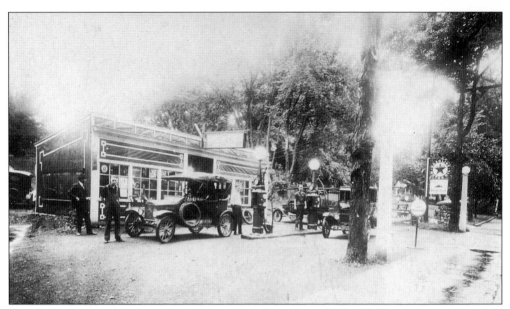

Flood's Service Station opened in 1919 on Hamilton Street by Joe V. Flood. Second from left is Mr. Wilder from Litchfield Avenue, and Calvin Wilson is standing at the rear bumper of the first automobile. Wilson became partners in the business with Flood, until Flood passed away. The two other men are unidentified. Wilson's wife, Edna, was bookkeeper. His son Roy operated the business until he retired in 2001 with his wife, Gloria, the bookkeeper. Their son Bryan along with his wife, Donna, are now at the helm, the third generation of Wilsons and wives operating continuously at the same location.

Probably in the early 1930s, Cal Wilson serves an unidentified customer in his vintage convertible coupe. The display case of automobile accessories was designed by Joe Flood. The shiny item on the bottom shelf is a heater. Many makes of cars did not come with heaters or directionals at that time.

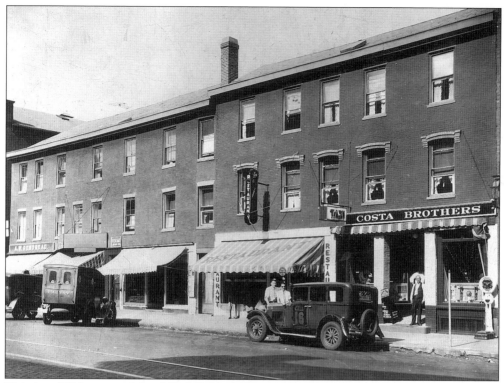

This is a 1930s view of the 300–308 block (Costa Brothers, Taxi and Restaurant) and the 312–324 block on Main Street. The 300–308 block is the oldest building on Main Street today. This building dates prior to 1826. The Town of Southbridge condemned the structure in 1998; it was then purchased by the town and stabilized in 1999–2000. The town intends to use the building as a museum.

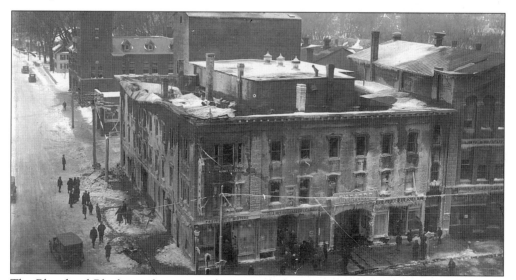

The Blanchard Block, on the corner of Main and Elm Streets, suffered two or three fires over the years. This one was in 1926. The building still stands, maybe because the fire station is only one block up the street.

This interesting view of the backs of buildings on Main Street was taken in 1930 from behind the post office. From the look of the ground, a new lawn was being planted. Today, however, the lawn has long been replaced with parking lots. The buildings along Main Street in this photograph are, from left to right, the back of the four-story YMCA building in the center of the photograph, the back of the Southbridge Savings Bank, and the Worcester County National Saving Bank building constructed in 1929. The steeple of the Central Baptist Church can be seen at the right of the photograph.

This is Main Street in a view looking west toward the Centre Village on July 23, 1923, at what is now the site of Dresser Park.

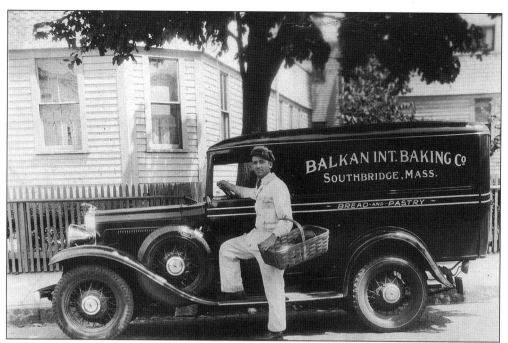

Standing with the company truck and his bread basket is Jimmy Peters in the early 1930s. Balkan International Baking Company was started in 1918 on Central Street, next to Billis' Diner, where the parking lot is today. After a fire in 1922, the business relocated to Worcester Street, opposite today's Johnson Tool & Manufacturing Company. At some point, the name changed to Sunrise Baking Company and existed until 1957, when United Lens Company bought the property to expand its factory.

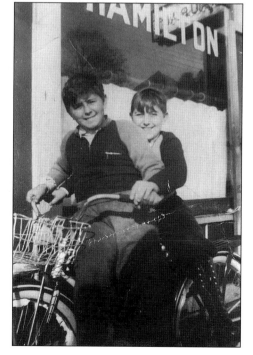

Two boys on one bicycle, Steve Tanionos and Pete Peters (in knickers and lace-up boots), are enjoying their afternoon in the sun in the late 1930s. The Hamilton Lunch was run by John Tanionos for a few years where the Little Kitchen is today on Hamilton Street in Globe Village.

Neighborhood markets were numerous. Elias Peters, born in Drenova, Albania, and his wife, Stella, born in Thessaloniki, Greece, came to America after they were married in 1927. After living in Putnam, Connecticut, and running a restaurant with his brother-in-law for a few years, he took employment at American Optical, and the couple settled in Southbridge. While employed at American Optical, he built this grocery store in the late 1930s, on the corner of Randolph Street and Green Avenue. The photograph was taken probably in the 1940s.

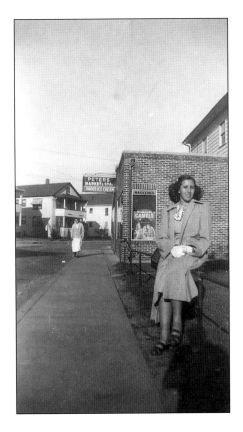

A little later in the 1940s, a brick front was added, built by local mason Dominic DiGregorio. Elias Peters is in front of the store. In the foreground is their daughter Maria (Dirlam) c. 1950. Peters retired in 1965, and the store was sold to Andy Petro. Some other neighborhood markets were Laportes, Pariseau's, Godro's, Therrien's, Nick Steven's, Saletnik's, Desautel's, Phil Monahan's, Liro's, Desaulnier's, Wonderlie's, Swirbliss', Palmerino's, Julian's, Gay's (Vespucci), Tiberri's, Michelis, Paoletti's, Kollios' Central Market, Roscioli's, Graf's, and Lippe's.

In this view, the Masonic Building, originally the Chester A. Dresser House, with the ornamental cupola, is featured. The building, one of the largest on Main Street, at the corner of Central, was new at the time. In the late 1960s, the building was beautifully restored by Honoré (Henry) Madore and Louis Ciprari and renamed the MACI Building. Unfortunately, in 1971, it was destroyed by fire and, tragically, Sandy Pappas, recently immigrated from Greece, lost his life.

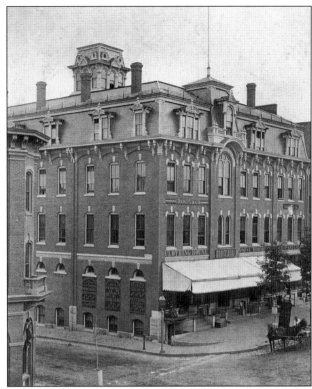

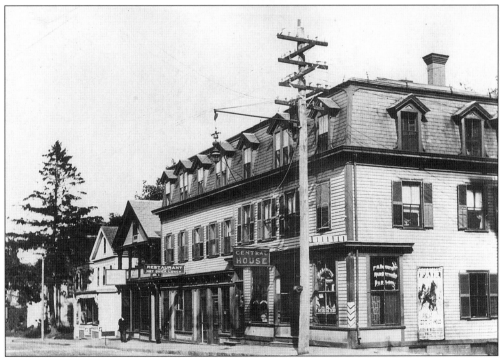

The Central House was located on the east side of Central Street. The building still remains though in a much altered state.

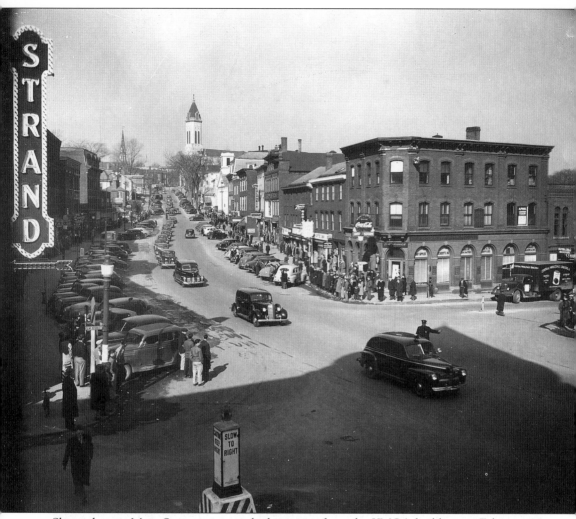

Shown here is Main Street in a view looking west from the YMCA building on February 14, 1947. The subject of this photograph is the funeral of Charles O. Cozzens, a vice president of the American Optical Company. The building in the center, located across the way, is the Hartwell block. This building was built in 1864 by Dr. Samuel Hartwell for use as a pharmacy after his old store, located in the Healy's Tavern building, was destroyed in the fire of 1863. There has been a pharmacy located in the Hartwell block from the time the building was built to the 1970s. The pharmacy has always been called Hartwell's despite there being different owners of the business. At the top center left is the tower of the Notre Dame Roman Catholic Church.

Two

INDUSTRY

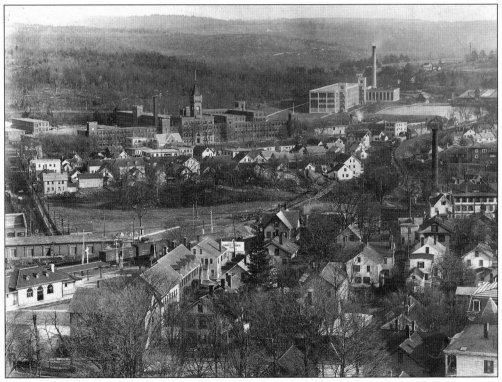

This is a 1914 view of the American Optical Company (AO), as photographed from the tower of the Notre Dame Roman Catholic Church, on Main Street. The AO buildings with the clock tower in the center were built between 1899 and 1907. The large plant to the right and behind the main AO complex is the "new" Lensdale complex constructed between 1909 and 1910. In the foreground to the left of the picture is the railroad station constructed in 1910. To the right of the train station are tenements and residential homes, many of which were torn down in later years to make room for parking lots and stores.

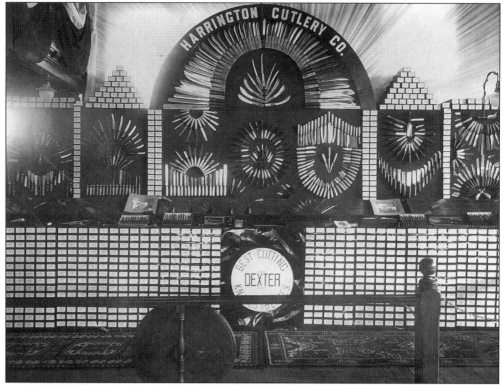

The Harrington Cutlery Company is the oldest manufacturing business still in business in the town of Southbridge. Henry Harrington founded the company in 1818 for the manufacturing of cutlery, razors, surgical instruments, and guns. The Dexter trademark was added in 1884 for Harrington's line of professional and industrial cutlery. In 1932, the Harrington Cutlery Company merged with the John Russell Company to become the Russell Harrington Cutlery Company.

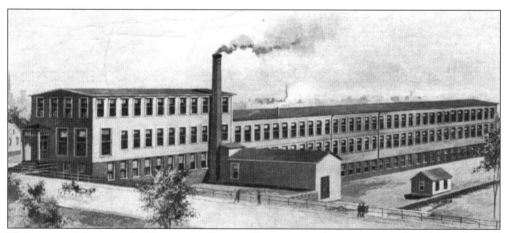

This postcard showing the Harrington Cutlery Company was given away at the 1907 Industrial Exhibition held at the Southbridge Town Hall.

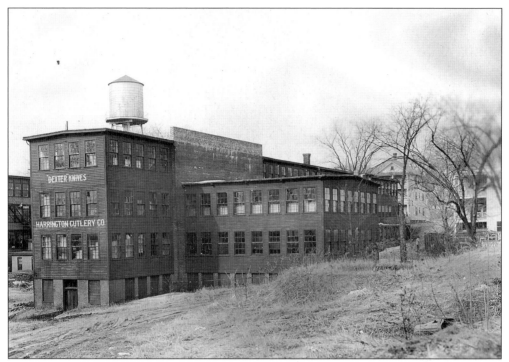

This is a *c.* 1920 rear view of the Harrington Cutlery Company, located on Marcy Street at what is now the site of the Head Start Day Care Center. The company relocated to its current site on River Street many years ago. The mill building had various uses after Russell Harrington relocated, its last use being a rooming house. The building was slated to be torn down to make room for the day-care center a few years back, but the building burned before the wrecking ball arrived.

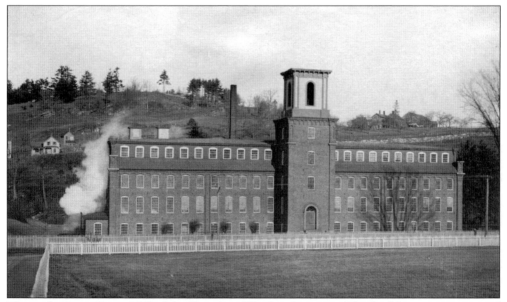

This is the River Street Mill of the Hamilton Woolen Company. This building was constructed in 1864. It is now the location of the Russell Harrington Cutlery Company.

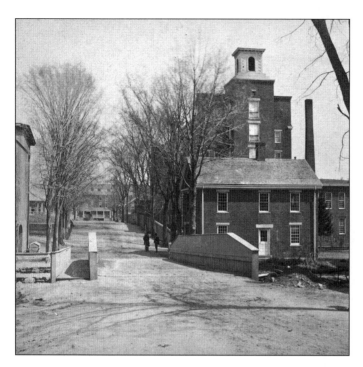

This 1880s image is a view looking north on Mill Street from the Mill Street Bridge. Over the bridge on the right is an office, and beyond the office is the Big Mill of the Hamilton Woolen Company. The Hamilton Woolen Company was the major concern in the Globe Village section of Southbridge; it operated from 1832 to 1936 and owned most of the real estate in "the Globe." A workers' strike in 1934, coupled with the strains of the Great Depression, led to the company's demise.

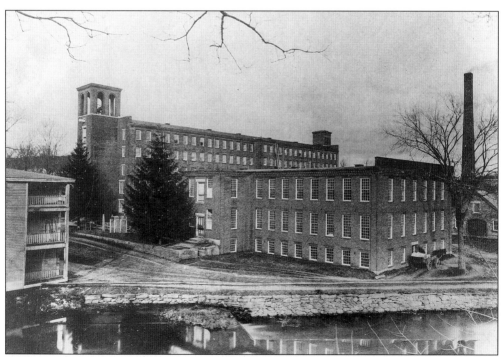

An image of the Big Mill of the Hamilton Woolen Company is seen in the background. It was built in 1836–1837. This is just one of the many mill buildings operated by Hamilton Woolen in the Globe section of Southbridge.

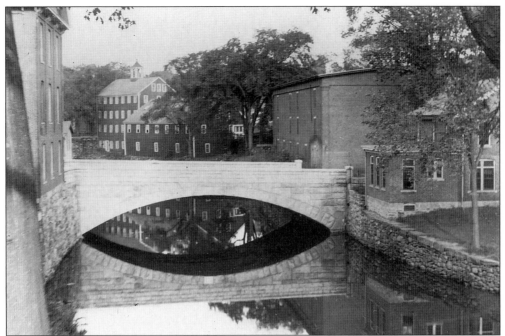

Seen here is a 1900 image of the Mill Street Bridge over the Quinebaug River. On the left is the rear of Gleason & Son's store. This brick building was at the corner of Hamilton and Mill Streets. In this view looking upstream over the bridge are the two wood-frame carpenter shop buildings (see pages 4 and 93), and next to the right is a brick store house. To the far right is an office building. All of these buildings belonged to the Hamilton Woolen Company, and none of them exist today. The bridge was replaced in the 1950s.

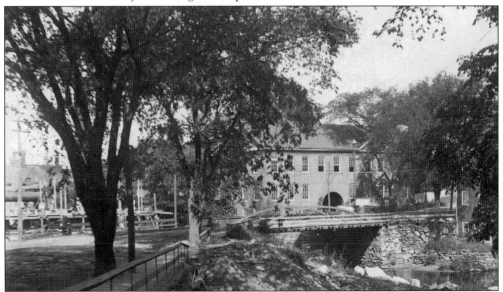

This is a 1905 view of Main Street looking west from the intersection of Mill and Main Streets in the Globe Village section of Southbridge. The bridge in this photograph is Main Street going over the Quinebaug River. All the buildings in this photograph were part of the Hamilton Woolen Company, none of which remain today.

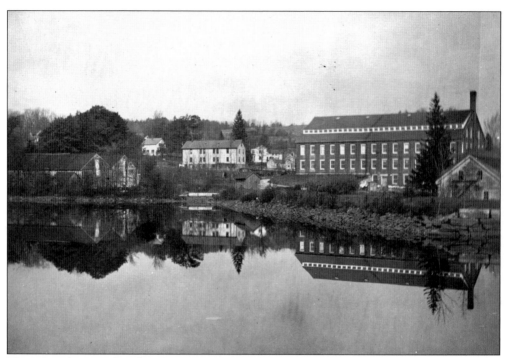

This 1910 photograph, taken from West Street, shows the "Big Pond" at the Hamilton Woolen Company. On the left are the icehouses where ice cut from the pond in winter was stored, and the large building to the right is the cotton mill of the Hamilton Woolen Company.

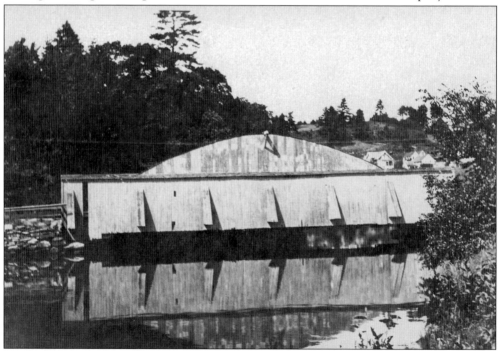

This 1895 view is of the River Street Bridge, built c. 1880. Rising in the background is the south end of Clemence Hill. The houses visible on the hill are located on Cliff Street.

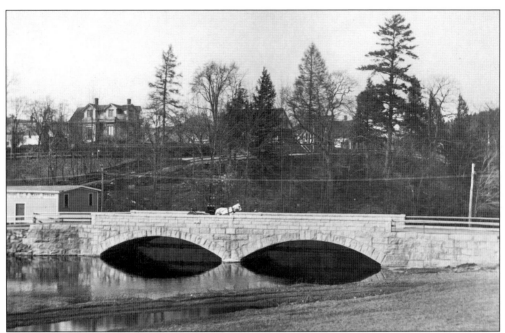

Shown in this photograph is the "new" River Street Bridge as it appeared in 1908. This bridge was replaced in the 1950s.

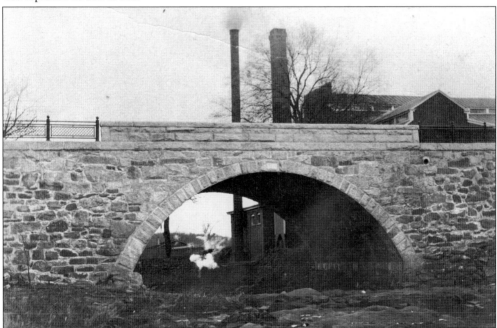

The graceful and historic stone arch bridge on Central Street has withstood the onslaught of several major floods over the years. One of them completely washed out the street on the left side. Fill was taken from Paige Hill (where the sign for Joe Capillo Park is located) to rebuild Central Street. The photographer stood in the riverbed to capture this view looking downstream. Part of the Central Mills complex is seen on the right in this postcard image, taken prior to 1910.

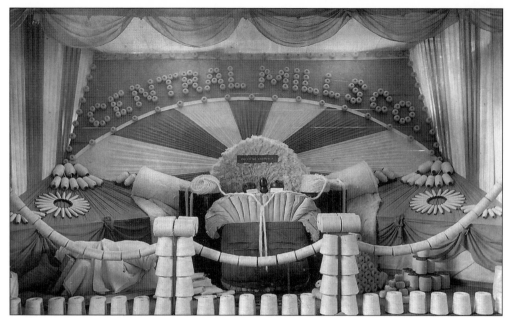

Central Mills Company had a long history in Southbridge; it dated back to 1814 and was organized under many different names and owners. Principle in the ownership of the firm were Ebenezer D. Ammidown, Linus Child, Manning Leonard, and Chester A. Dresser. The Central Mills Company was formed from the merger of two companies—the Southbridge Factory Company and the Dresser Manufacturing Company—and operated under the name of the Central Manufacturing Company until 1859, when it was incorporated as the Central Mills Company. The firm operated until the late 1920s and produced cotton products.

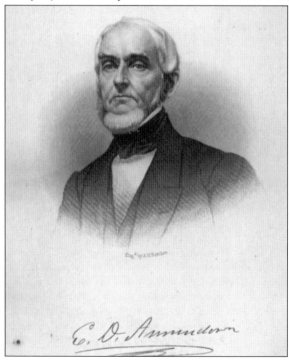

Ebenezer D. Ammidown was an owner and major investor in what would become Central Mills. He was also involved in many other business endeavors in town. Ammidown was born in 1796 and died in 1865. Besides his involvement in local businesses, he was elected to both the state legislature and senate. He was instrumental in bringing the railroad to Southbridge, as well as the construction of many roads in the area.

Manning Leonard was also an owner and investor in what would become Central Mills. He was born in 1814 and died in 1885. Leonard traveled and worked in New York City as well as Madison, Indiana, before settling in Southbridge in 1844 (he was originally from Sturbridge). He married Mary F. Ammidown, daughter of Ebenezer D. Ammidown, in 1840. His involvement in Central Mills began in 1845 and ended in 1859 due to health problems. He was elected to the board of selectmen and the state legislature. He was also a banker.

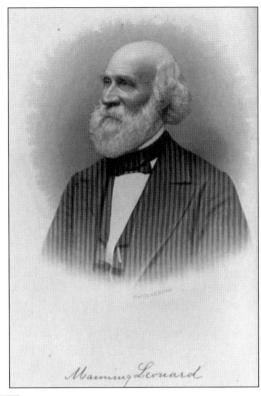

Manning Leonard

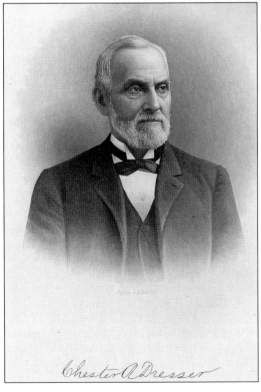

Chester A Dresser

Chester A. Dresser, a later partner and then director of the Central Mills Company, was born in 1818 and died in 1899. Dresser was a nephew of Ebenezer D. Ammidown and was orphaned at age 10, when his mother died. Ammidown was appointed Dresser's guardian. He apprenticed at various mills locally and out of state. He became superintendent of Dresser Manufacturing Company in 1845. This position led him eventually to owning the Central Mills Company.

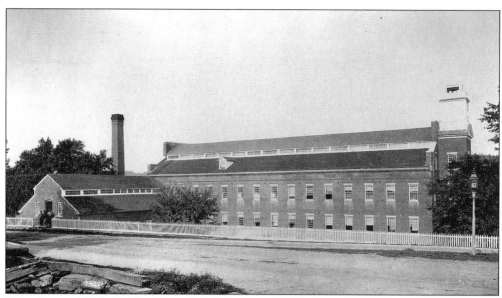

This photograph shows the Central Mills Company, located at the intersection of Foster and Central Streets, as it appeared in 1875. The building in this image was constructed in 1837. The southern part of the building was replaced between 1908 and 1910 by the mill building currently standing on the site. The remaining north section of the 1837 mill can still be seen from Central Street near the bridge over the Quinebaug River.

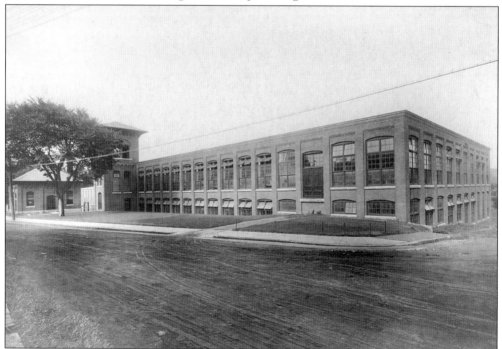

The Central Mills Company plant is shown in the early 1900s. Although Central Mills ceased operations in the 1920s, the building went on to house such businesses as F.X. Laliberte & Son, the E.J. Martin Company, and Southbridge Lumber. Boniface Tool and Die still occupies the complex today, as do other concerns.

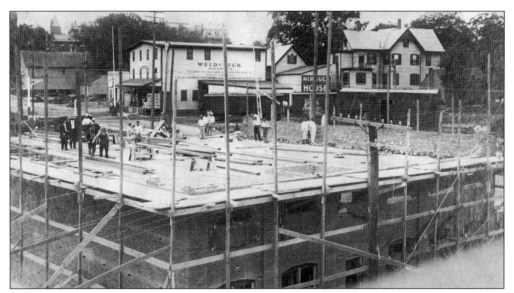

Shown here under construction is what is now the Southbridge Water Supply Company building on Foster Street. Founded in 1880, the water company had offices above Southbridge Savings Bank and worked out of the large barn in the upper left. Originally built by the Central Mills, it served as a warehouse for the company's finished product. Later, in 1942, the building was bought by Bousquet Auto Parts. After a fire in 1960, it was sold to the water company. Two boxcars rest on the rail siding adjacent to Weld & Beck Company. The Baptist steeple and Southbridge Town Hall tower are visible in the upper left corner.

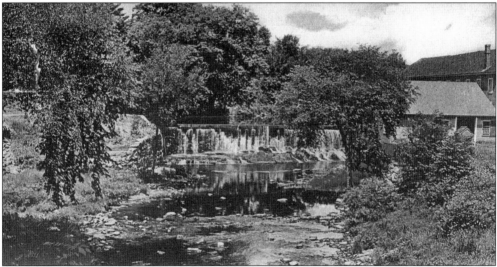

In the early 1730s, Moses Marcy built a sawmill and, in 1733, added a gristmill. These were the first businesses established in what would become Southbridge. The location was just upstream from the site of the Central Street bridge. At that time, this was part of Sturbridge. Later, in the early 1800s, the Central Mills began textile manufacturing, and the water rights from this dam became the company's. A canal ran under Central Street just south of the bridge and into the mill buildings. This was the view from the bridge for a very long time. On the right are the Central Manufacturing Company's twine mill buildings at what is now Twinehurst Place. The dam was destroyed in one of the floods in the 20th century.

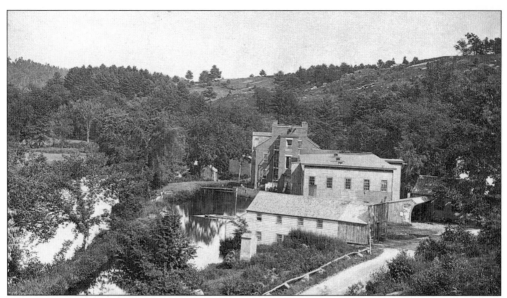

This 1875 photograph shows the Southbridge Manufacturing Company's Columbian Mill at the current site of the Lensdale section of the American Optical Company complex. The first Columbian Cotton Mill was constructed on this site in 1821. That mill was destroyed by a fire in 1844. The mill in the photograph was constructed in 1856 by E. Ammidown and used for the manufacture of cotton jeans and flannels. In 1866, it was sold to Henry T. Grant of Providence, Rhode Island. It was foreclosed in 1879 and burned shortly afterward.

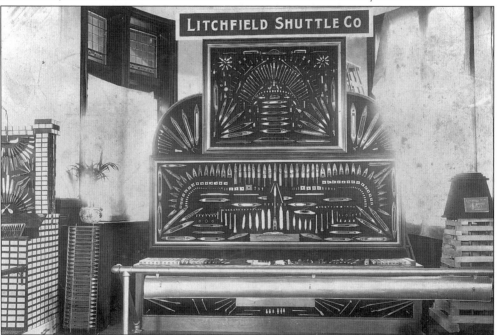

The Litchfield Shuttle Company was formed in 1848 as the L.O.P. Litchfield and Company and incorporated in 1878 as the Litchfield Shuttle Company, with a capital investment of $21,000. This company was known as the world's largest producer of shuttles and shuttle irons for use in the textile industry. The company operated to the early 1940s.

These two photographs show the Litchfield Shuttle Company from different directions and at different times. The older view, in 1908, is from (Old) South Street, which goes to the Westville Recreation area just past Trahan Brothers Masonry Supply business. The later view is from just upstream where the Quinebaug River makes the 90 degree bend, parallel to the old road. All that remains of this once important manufacturer are some of its floors—the concrete pads that people fish from opposite the Westville boat ramp. This section of Southbridge was known as Shuttleville, and the Sturbridge side of the river was called Westville.

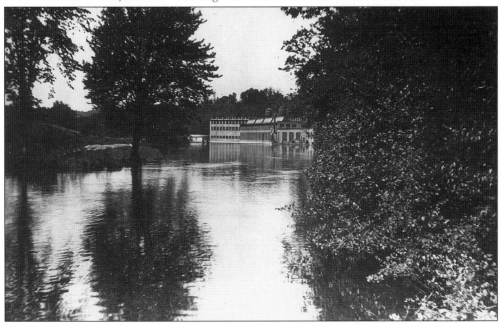

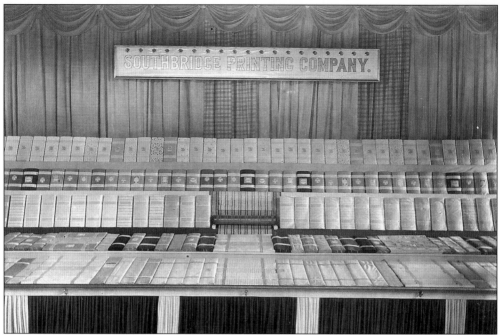

The first major industry in the Sandersdale section of Southbridge was the T & JH Sanders Company, founded by John Sanders in 1874 in the Ashland section of Southbridge (now known as Sandersdale). By 1875, the company was known as the Southbridge Print Works. In 1884, it was incorporated as the Southbridge Printing Company, where cotton was finished.

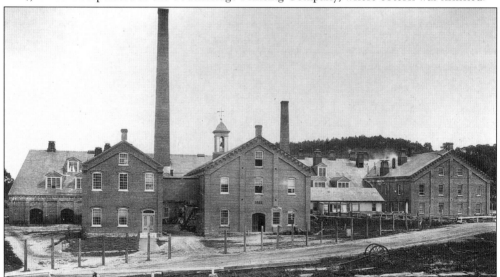

In a view looking across what would become East Main Street, we see the west side of Southbridge Print Works in 1875. The two-story brick building on the left housed offices, where Village Drive is now. From the 1920s to c. 1946, Herbert W. Wilkinson Sr. advanced from superintendent to vice president. The company was producing polished cotton and fine goods for Sears Roebuck and others. During World War II, the company ran full tilt, according to Wilkinson's daughter Jean Earnest. After the war, operations here ceased. The company moved south for cheaper labor.

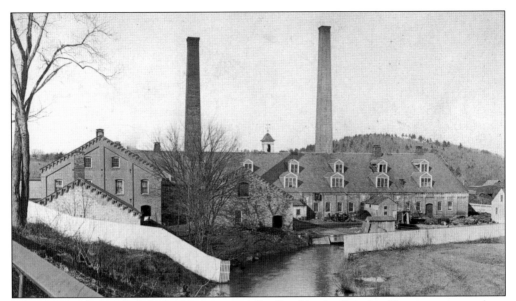

Lebanon Brook provided some of the power to the Southbridge Printing Company, as seen here flowing into the mills from under East Main Street in this late-1800s image. From the 1920s until it closed in the late 1940s, it was known as Southbridge Finishing Company.

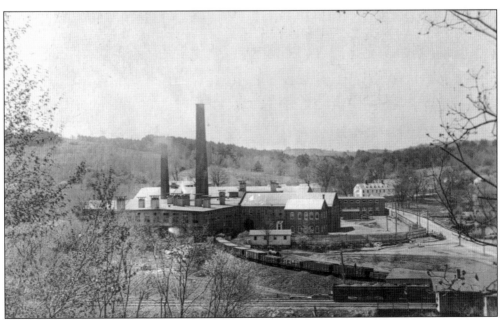

From the top of the high ledge, at the foot of Dresser Hill Road and Dudley River Road in a view looking south, we get this bird's-eye view of the Southbridge Print Works complex. In the foreground is the rail spur into town. A number of cars sit on the factory siding. The white house on the right is on the corner of Ashland Avenue and East Main Street. Brookside Apartments occupies this site today. The date of this image is uncertain.

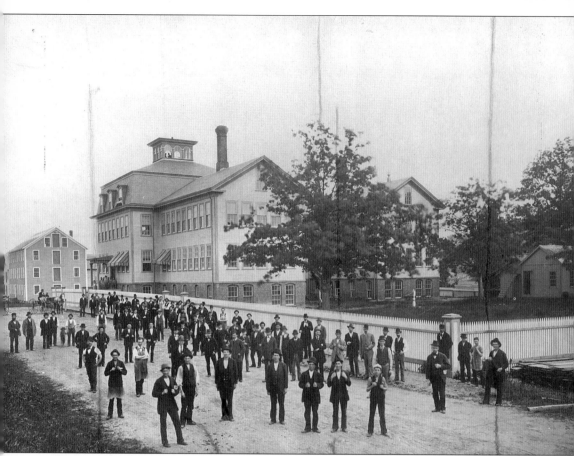

This is an 1872 view of workers in front of the American Optical Company complex on Mechanic Street. The premier manufacturer in the town of Southbridge up until the 1970s was the American Optical Company. The company was first started in 1833 by William Beecher in a building that stood at the corner of Central and Main Streets. Beecher was a jeweler by trade and started making eyeglass frames as part of his business. He employed four persons in 1833. The company went through various owners until 1869, when it became the American Optical Company, with Robert H. Cole as president, George W. Wells as treasurer, and H.C. Cady as superintendent. At that time, the company was located next to the railroad tracks on Main Street, where Chestnut Street is today. The company prospered until the 1960s. Starting in the mid-1960s to the early 1980s, the company had fallen on tough times and began selling off its divisions to competitors. The company still has a small presence in Southbridge. In 2000 and 2001, the Mechanic Street complex has been rebuilt to serve as a Department of Defense training facility, hotel, and conference center.

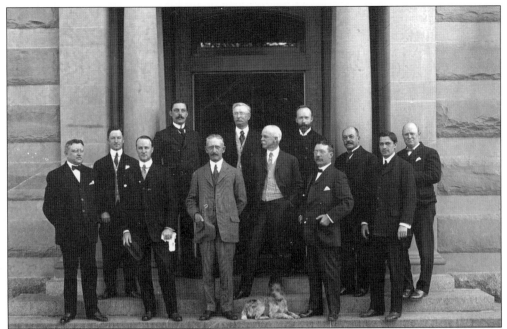

The owners and executives pose in front of the American Optical headquarters *c.* 1910–1912. Sixth from the left is George W. Wells (1846–1912). Second and third from the left are Joel Cheney Wells (1874–1960) and Channing McGregory Wells (1870–1959), respectively. On the far right is Albert Bacheller Wells (1872–1953). They were the three sons of George Wells. Seventh and ninth from the left are Henry Cady and Nelson Baker, respectively.

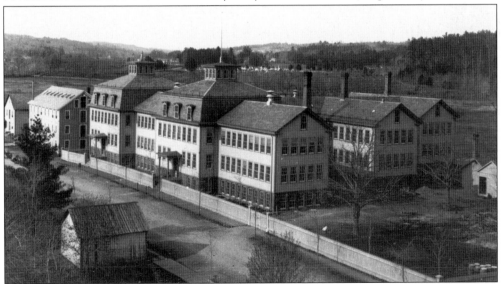

In 1872, the company opened its first factory at the current site of the American Optical complex on Mechanic Street. Additions to this factory were made in 1879, 1882, and 1886. The lens factory was built in 1887 at Lensdale. By 1899, the company had outgrown its facilities, and a new complex was constructed between 1899 and 1907 on Mechanic Street and constructed in 1910 for Lensdale. Other buildings were added to the company complex into the mid-1900s as the company grew.

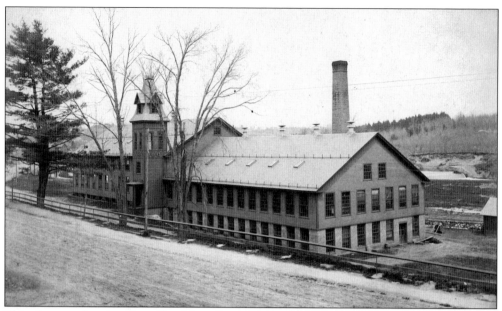

This photograph, taken from East Main Street, shows Lensdale as it appeared in 1888.

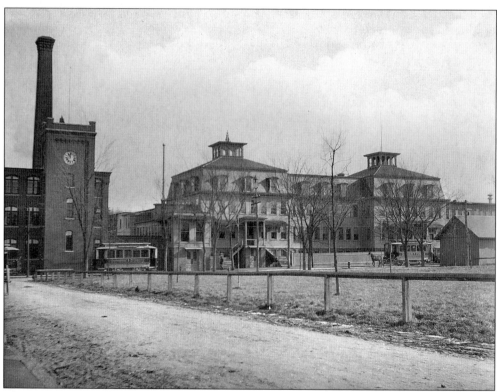

This 1900 view shows the old main plant of the American Optical complex alongside the new brick north section. Note the trolleys of the Southbridge and Sturbridge Street Car Company and the horse-drawn carriage.

Office workers are seen here exiting the American Optical main plant and awaiting conveyances *c.* 1900.

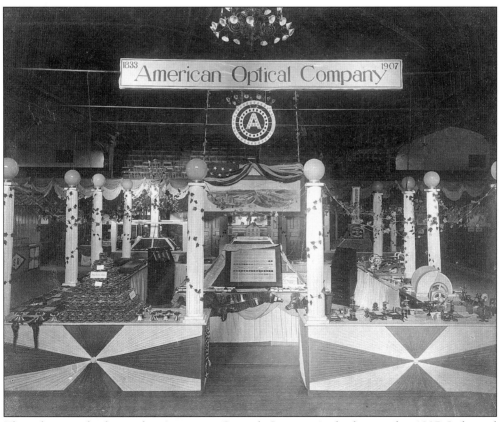

This photograph shows the American Optical Company's display at the 1907 Industrial Exhibition, held at the town hall.

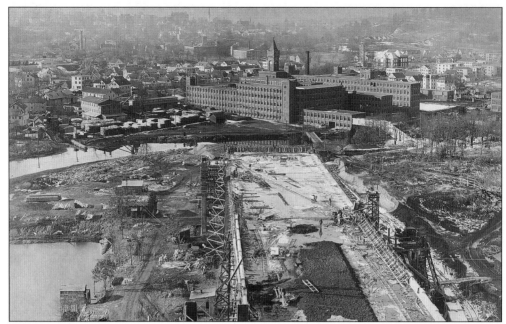

This is a 1909 photograph of the American Optical Company's main plant in the background and the construction site of the "new" Lensdale building in the foreground. The Quinebaug River flows between them. The covered bridge on the right center of the photograph was known as the "tunnel," in which heating and electrical lines ran from the power plant to the main plant.

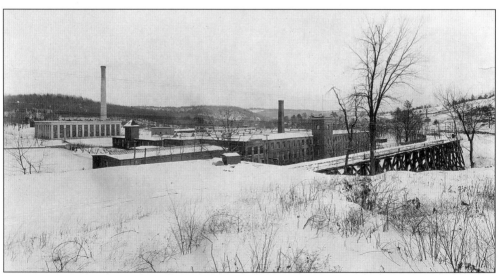

This is a winter view of the "old" Lensdale Plant in the foreground center and the "new" Lensdale Plant in the background, on the left, considered to be the largest poured-concrete building in the world at that time (1910). The old Lensdale Plant became known as Casedale because eyeglass cases were made there. In the foreground is a railroad spur used by American Optical into the 1960s.

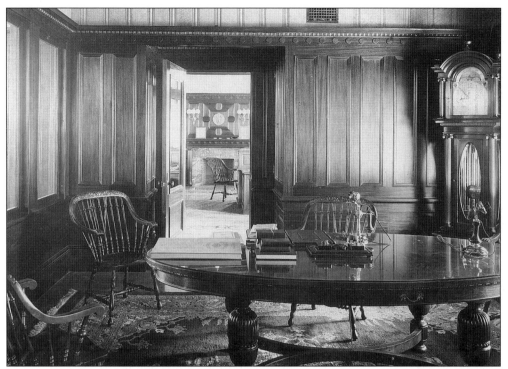

This 1912 photograph shows the presidential office suite, located in the clock tower building of the American Optical complex main plant on Mechanic Street. In the foreground is a conference room, and in the background is the president's office. The president's office had two entrances. One was the public entry through the doorway. A second, concealed means of entry or exit was located to the left of the fireplace; it went through a small closet into an office area beyond the executive offices.

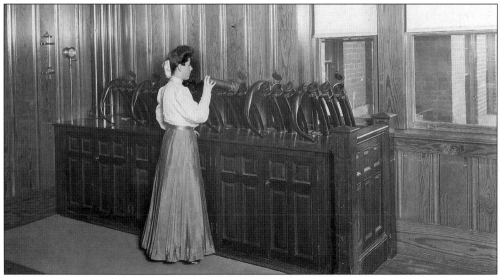

This 1912 photograph shows the pneumatic tube console located on the first floor of the American Optical complex main plant. From here, notices could be sent anywhere in the complex. The system was state of the art in 1912.

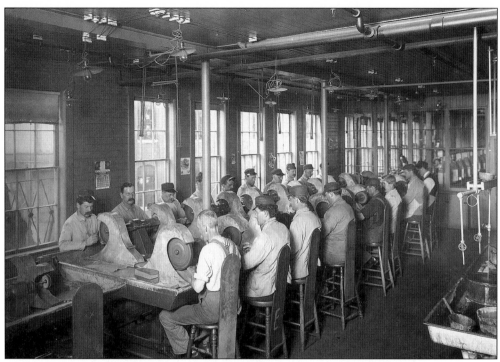

Workers are grinding eyeglass lenses in 1912 at one of the American Optical grinding shops.

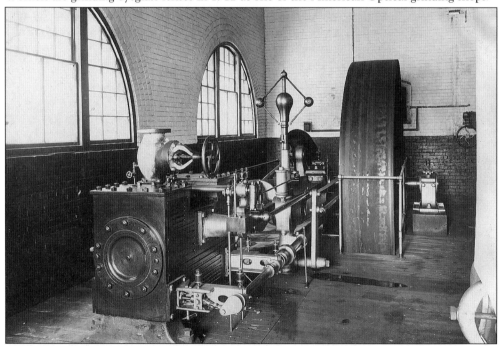

This photograph shows the "Green" steam engine as it appeared in 1900. This engine was located in the main plant of the American Optical complex and drove a three-inch shaft, which ran the length of the Mechanic Street building. George Williams and Mr. Greenwood were two engineers responsible for running this engine.

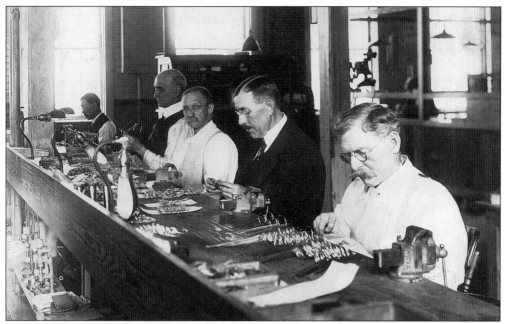

The dignified-looking gentlemen in this 1910 photograph were at the top of the frame-making establishment at American Optical. They worked in the gold department manufacturing gold eyeglass frames. From left to right are Mr. Guilette, John Anderson, "Chick" Lombard, Robert Gough, and George Armes.

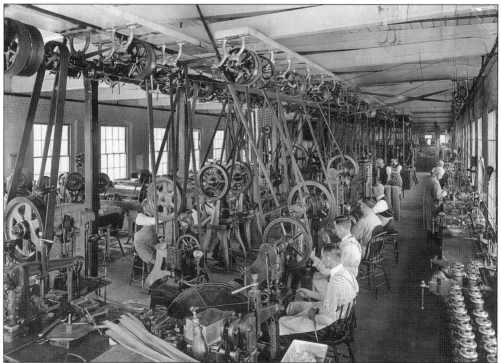

The men in this 1917 photograph are producing eyeglass frame wire. The noise of the belts and pulleys must have been very loud, not to mention dangerous.

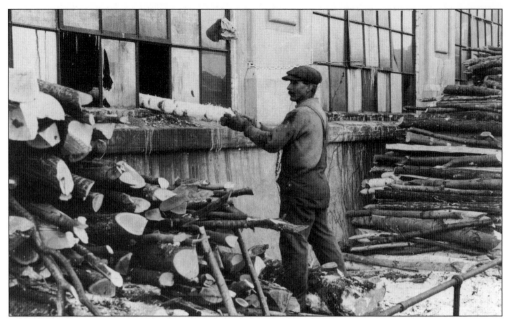

This 1918 photograph plainly shows the effects of war on industry. In the winter of 1918, while the United States was in the heat of battle during World War I, much of the coal produced in this country went to supply the war effort, leaving a coal shortage that affected just about everyone in the nation, including the American Optical Company. Pictured here is American Optical's solution—burning cordwood to supplement its use of coal. The worker pictured is feeding wood into the company's power plant.

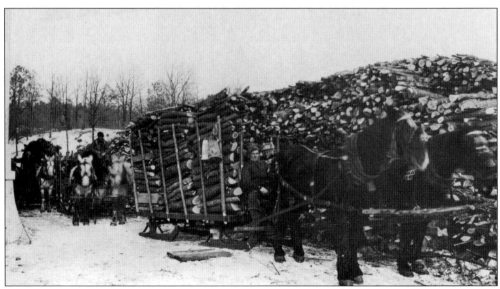

Pictured here are horse teams delivering cordwood to the power plant in the winter of 1918.

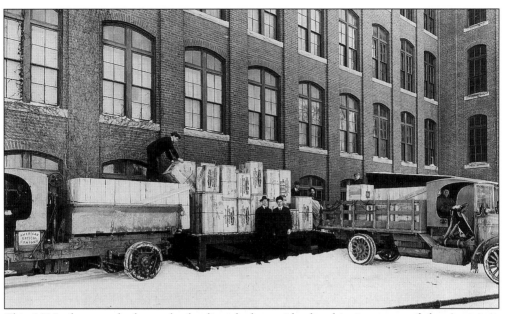

This 1918 photograph shows the loading dock outside the shipping room of the American Optical main plant. Driving a truck in 1918 must not have been much fun; for one thing, there was not any heat, as can be seen in this image. Note the chains on the rear wheels for traction in the snow.

The workers in this 1918 photograph have the unfortunate task of preparing emery for lens grinding.

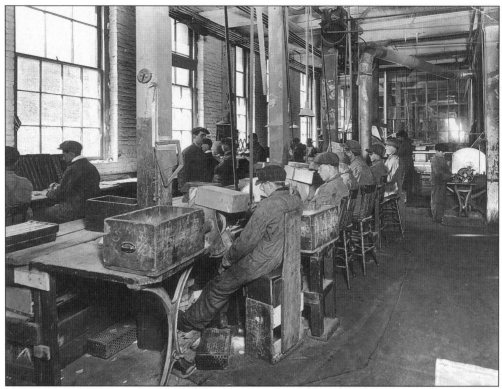

American Optical grinders are seen here at work in 1918. They all seem to have fine chairs except for the worker in the foreground. Is he the new man on the job?

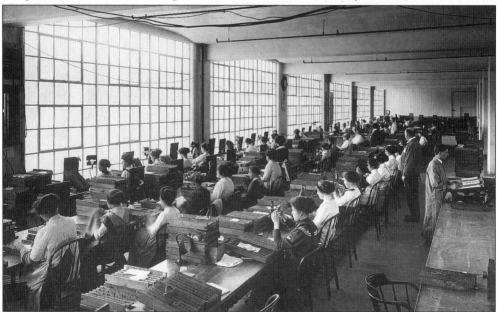

This view shows women in the workforce *c.* 1920. These ladies are eyeglass-frame makers, working at American Optical. From the look of the windows and the ceiling, this workshop looks to be located in the "new" Lensdale building.

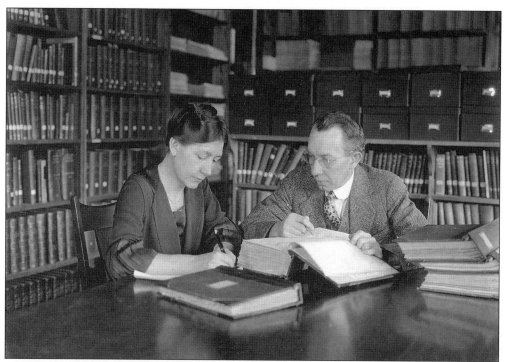

Dr. Estelle Glancy, a mathematician, and Dr. E.D. Tillyer, American Optical scientist, are seen hard at work in this 1920s photograph.

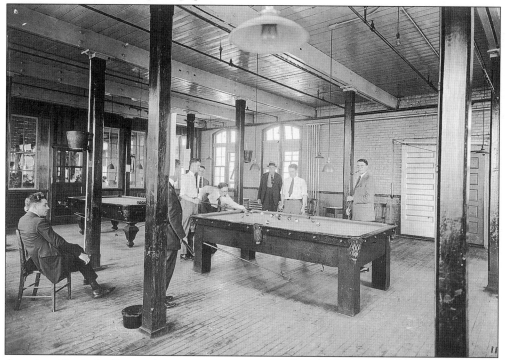

American Optical office workers are enjoying a game of pool in the company's recreation room in 1920.

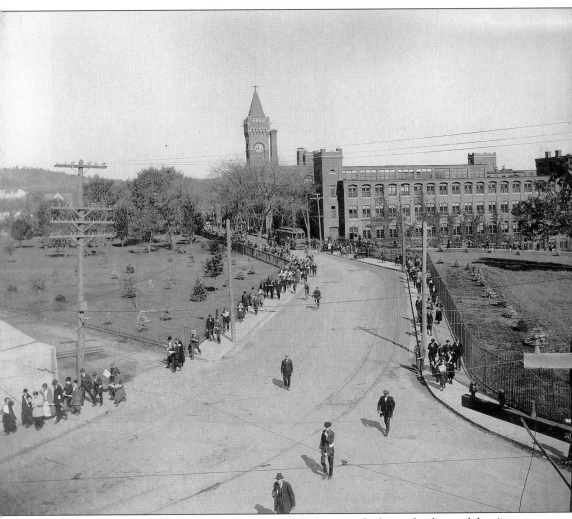

Workers are heading home for lunch. This 1925 photograph shows the front of the American Optical Company. Note the time on the clock in the tower. Lunch break began for the plant workers at 11:45 a.m. A typical worker at the American Optical Company would start the day at 7:00 a.m. Lunch was from 11:45 a.m. to 1:10 p.m., and work ended for the day at 5:00 p.m. On the lower left of this photograph can be seen a railroad abutment for the Southern New England Railroad. The Southern New England was to be a branch of the Grand Trunk Railroad. Unfortunately, after laying some 80 miles of track between Providence, Rhode Island, and Palmer, Massachusetts, the railroad closed down in 1926 without ever running a commercial train on its tracks. Note also the trolley car of the Southbridge and Sturbridge Street Car Line in front of the plant. Streetcar service in Southbridge began in 1897 and lasted until 1928. Also of interest is the lack of the rotary in the foreground of the picture. The rotary was added in the 1930s.

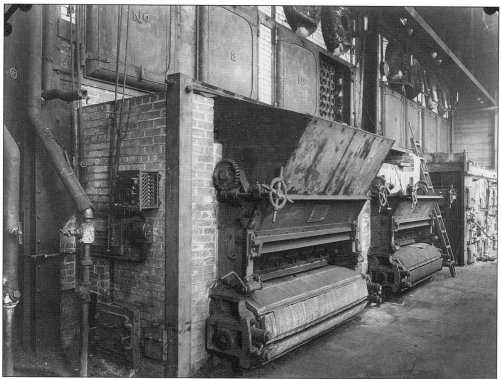

This 1921 photograph of the American Optical Company power plant shows soft coal feeders to steam boilers. In later years, the boilers were converted to oil.

This photograph shows trucks and drivers of the American Optical fleet in 1925.

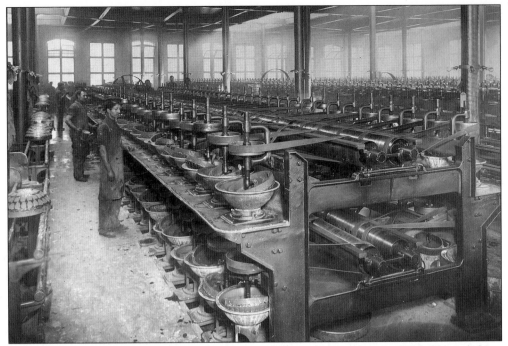

This is one of the polishing rooms at the American Optical main plant in 1912. The polishing department was known as "the rouge" due to the red clay polishing compound used. From the looks of the workers in this photograph, it was a dirty job.

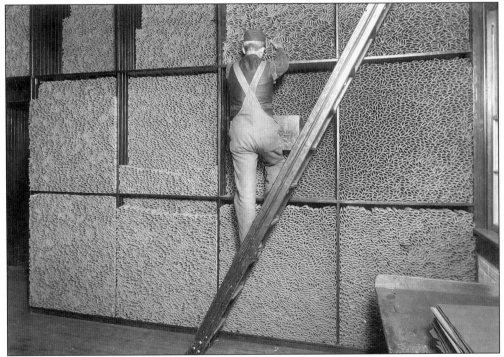

The American Optical worker in this 1912 photograph is placing eyeglass cases into their appropriate bins.

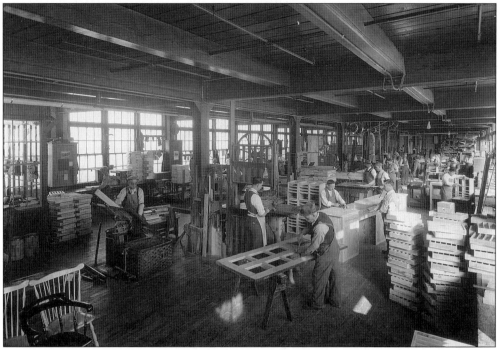

This is the American Optical main plant carpenter shop. This 1928 photograph shows the variety of tasks handled by the American Optical carpenters. In the foreground, on the left, are chairs. In the center foreground, a carpenter is working on a door and, behind him, carpenters are building a workbench. All this—in addition to the display cases, drawers, and shelves seen everywhere in this photograph—were built by the carpenters.

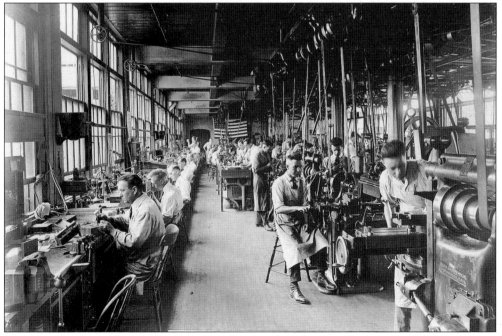

These are American Optical Company workers employed in the die room *c.* 1928.

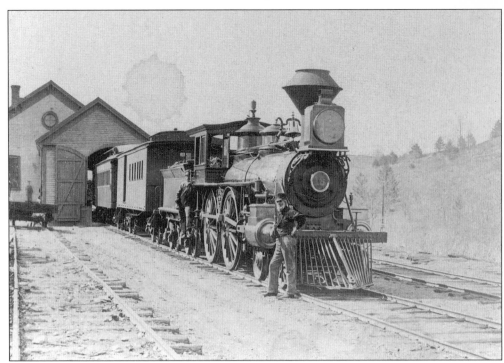

By 1868, Southbridge was connected to places near and far by the Boston, Hartford, and Erie Railroad. This image shows a classic early locomotive and wooden coaches on Crane Street with the train shed and freight house in 1868. At this time, passengers could go from Southbridge to Boston without changing trains.

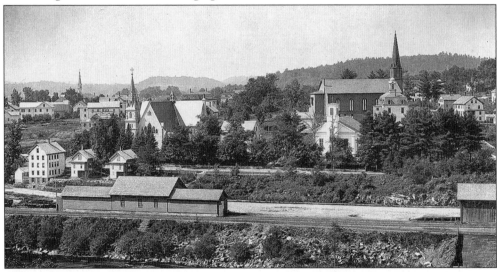

The New York and New England Railroad into Southbridge came from Webster and terminated on Crane Street. It was always a dead-end spur and never a through route. The three-section building on the left was probably a carbarn. Part of the freighthouse, which burned in the 1980s, is visible on the right. In the background, from left to right, are the steeple of the Methodist church, St. Mary's Church, St. Mary's School (St. Peter's Church), and Notre Dame (Pine Street). This was the view from Paige Hill in 1875.

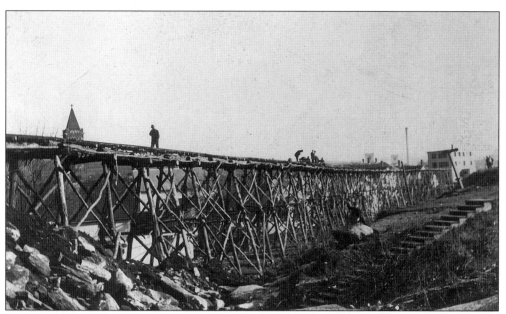

Construction of the Southern New England Railroad (the Grand Trunk) was well underway when this view of the "long fill at the Flat" was taken on November 22, 1913. This section of the railroad was in the Crystal and North Street area. The new American Optical brick clock tower is visible in the background. The clock was installed by Gaetano Buccelli, grandfather of Joanne Buccelli Zotos.

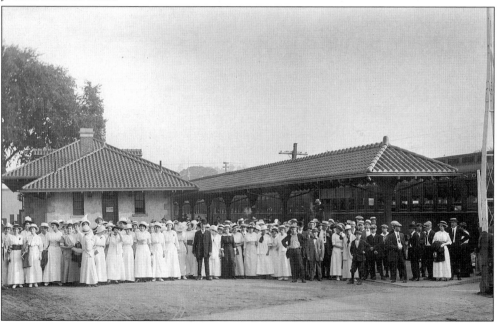

The New York, New Haven, and Hartford Railroad built this passenger station in 1910, in the style that came to be known as New Haven Spanish, due to its design features of stucco walls, arched windows, and terra-cotta roof tiles. This large throng is posing before boarding the cars sometime between 1910 and 1920. Ownership and names of the railroad changed a number of times over the years.

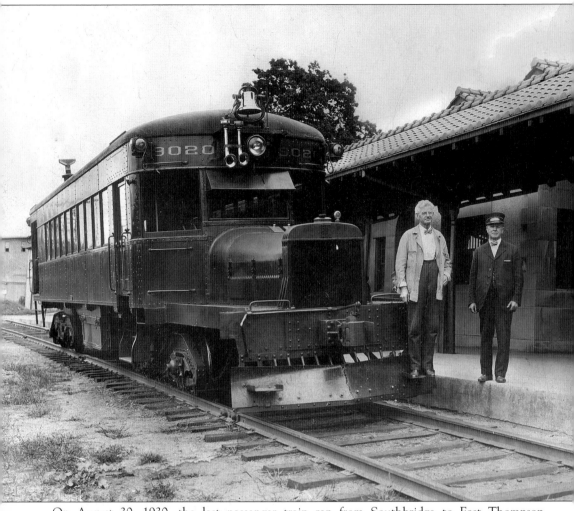

On August 30, 1930, the last passenger train ran from Southbridge to East Thompson (Connecticut). The engineer of this rail bus was Luther Stoodley, and Joseph Breen was the conductor. East Thompson was a busy rail junction and the location of the only known four-train wreck in history in the 1890s. A Southbridge local train was involved in that disaster.

Three

At School
and Church

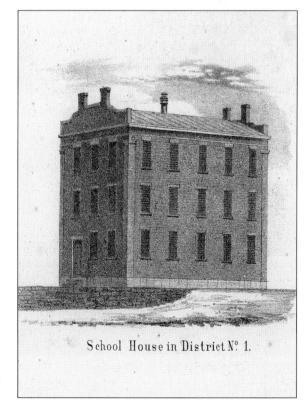

School House in District Nº 1.

What we remember as the old police station on Main Street was originally the district No. 1 schoolhouse, built in 1816, the year Southbridge was incorporated. Primary pupils were taught here for well over 100 years. This image is a lithograph, before the time of photography.

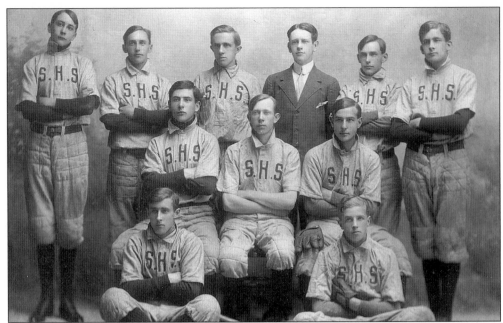

Southbridge High School fielded this strong and determined team for the 1907–1908 season. They look like they are ready to play ball! From left to right are the following: (front row) Eaton and Hanson; (middle row) Dumas, Senior, and Lewis; (back row) Bagley, Ernest Hall, Williams, Cozzens, J. Hall, and Upham.

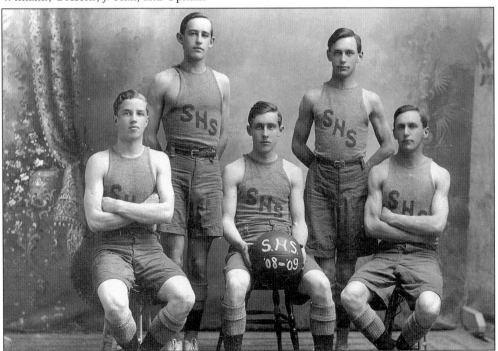

Here are the Southbridge High School five for the following basketball season. These boys are not identified, but some of them seem to resemble some of last year's baseball players. High school was held in the Southbridge Town Hall in those years.

The Elm Street School, with a well-worn schoolyard, stood in the southeast corner of Elm and Summer Streets. The building had fine details, such as the unusual dormers and trim along the eaves and over the windows, the slate roof of rounded shingles, and a stout chimney. This was a well-built and handsome public school. Parked in the shade on Summer Street is someone's new automobile on June 10, 1914.

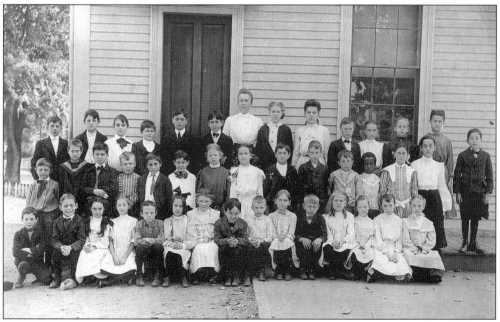

The pupils in this undated group portrait pose in front of the Elm Street School. Several grades were probably taught here, judging by the ages of the children—all dressed up for this occasion.

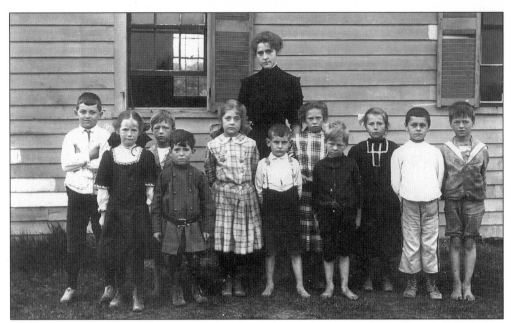

Standing outside the Lebanon Hill School *c.* 1908–1910 is this nice small class of first- and second-graders with their young teacher. The pupil fifth from the left is Mildred Apte. This building was located just beyond Brickyard Road (now Alpine Drive) and vacated in 1936. The teacher may have been Pauline Roy.

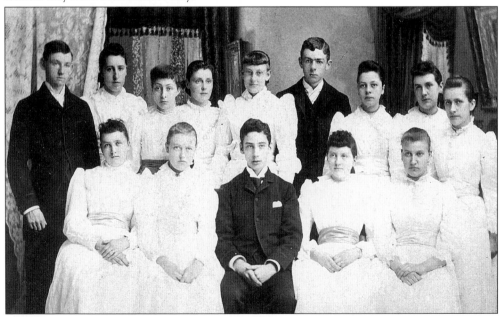

The three males in this rather formal portrait of the Southbridge High School Class of 1891 probably got a lot of attention from their classmates. From left to right are the following: (front row) Emily Clemence, Elizabeth Wood Booth (Clarke), John Clarke, Florence Pearl Oakes, and Annie Maria Newell; (back row) Arthur Dubey, Alice Maria Boardman, Lucy McKinstry, Jacobina Walker Taylor (Bugby), Carrie Estelle Booth (Harris), Myron Broadbent Clemence, Carrie Louise Hill (Smith), Edna Blanche Litchfield, and Mattie Jane Plimpton.

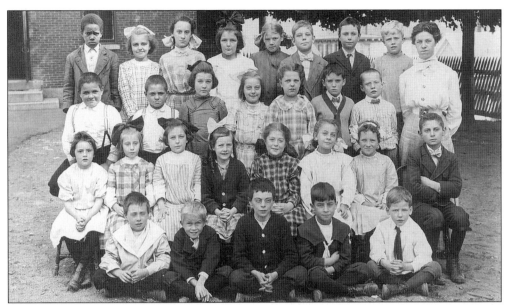

Now we are in front of the Main Street School *c.* 1910. Second from the left in the second row is Daisy Apte. Fifth from the left is Mildred Apte. This building later became a courthouse and, finally, the old police station. The police department vacated this building in June 1997. It was razed on November 11, 1999.

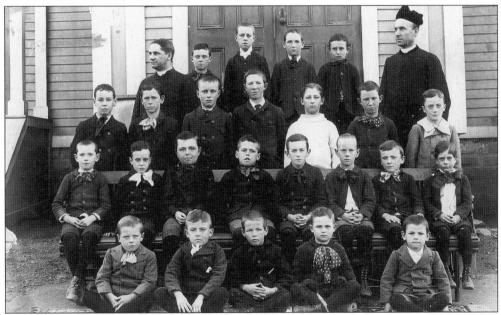

St. Mary's schoolboys are shown here looking very dressed up in front of the school *c.* 1895. They are, from left to right, as follows: (first row) J. Splaine, J. Hefner, L. King, J. Kelly, and B. Whalen; (second row) F. Pendergast, G. Doyle, M. Holden, J. Greeley, C. Clark, M. Brennan, M. Morrill, and T. McGrail; (third row) J. Curran, M. McGrath, J. Coughlin, M. Collins, M. Ward, T. Collins, and G. Silk; (fourth row) Father Griffin, W. Kelley, T. Burke, J. Curboy, C. Tetrault, and Father Drennan. The boys appear serious. The priests were probably strict. Why are they looking to their right?

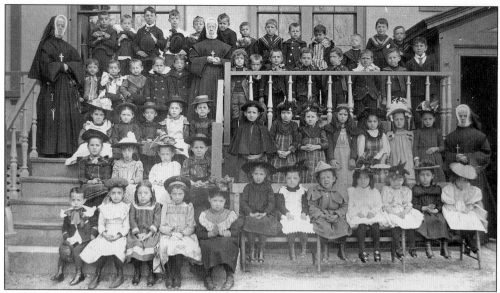

There are 55 first-graders in this *c.* 1896 image on the steps of Notre Dame School on Pine Street. All are dressed up. Hats and sailor suits are in fashion. The nuns' habits are rather severe. All the parochial schools had large enrollments.

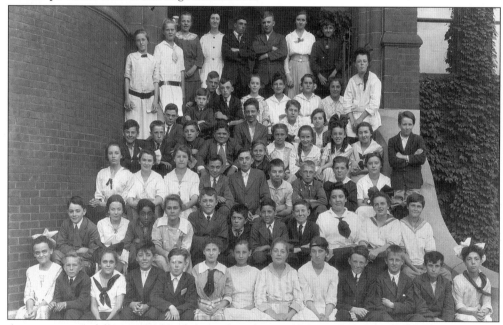

As we continue following Mildred Apte along her path through the public school system, we now find her in the eighth grade on the front steps of Marcy Street School, sixth from the right in front. Thecla Fitzgerald is third from the right in the second row. The year is 1916. This school accommodated the middle grades. Some of the other neighborhood schools housing the early grades included the Dennison School on Dennison Lane, Bacon School on North Woodstock Road at the corner of Tipton Rock Road, and the Ammidown School in Sandersdale, somewhere on Ashland Avenue heading toward Dudley. One other, the Union Street School, was demolished in 1912.

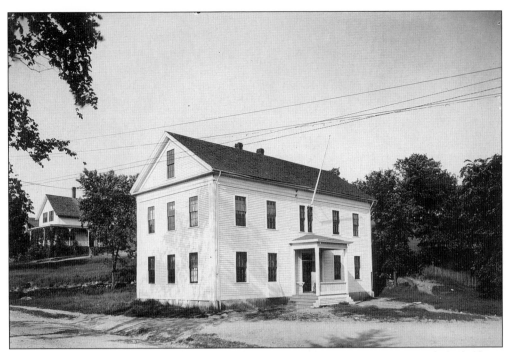

The River Street School is shown in June 1914. This Greek Revival and fairly large neighborhood school was probably built in the second half of the 19th century. In 1885, the Plimpton Street School was closed and united with River Street.

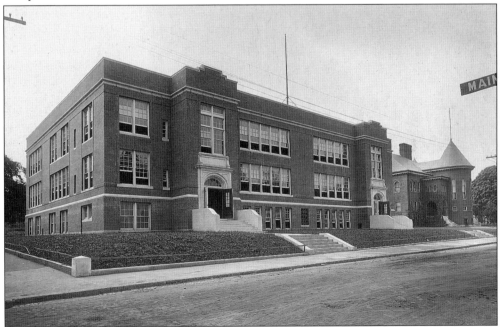

This view shows the new Southbridge high school, the Mary E. Wells High School, at the corner of Main and Marcy Streets after it was built in 1917. One wonders how the students fit in the Southbridge Town Hall before this school opened. To the right is the imposing Marcy Street School, which was demolished (with some difficulty) in the mid-1960s.

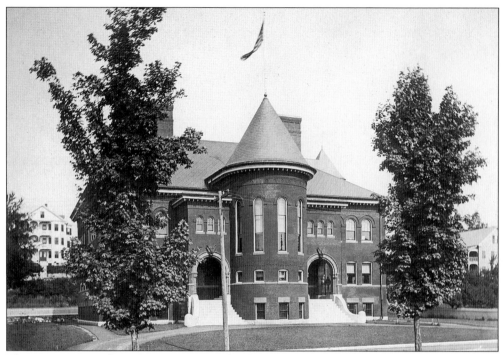

This is a very nice shot of Marcy Street School from across the street. Gracing the arches over the front steps were cast eagles. Two have been preserved at the Fraternal Order of Eagles Club on Mill Street.

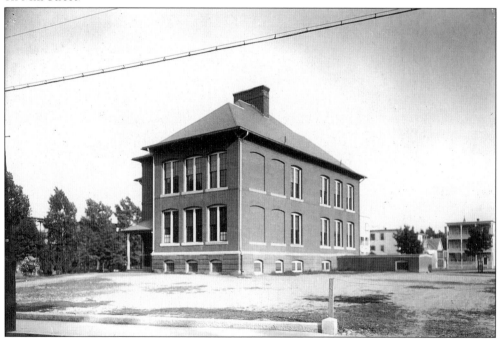

In another of the June 1914 shots, we see the Mechanic Street (Grammar) School, where the high-rise building stands today at 60 Mechanic Street. The public school was in the same block as the much larger Sacred Heart School. This view was from the Charlton Street side.

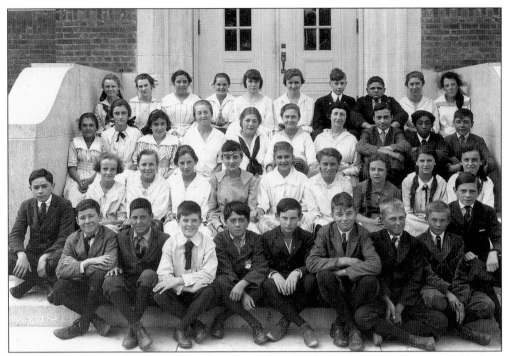

Here on the steps of the new Mary E. Wells High School, in 1917, is grade nine. Fifth from the left in the third row is our friend Mildred Apte. Third from the left in the back row is Thecla Fitzgerald.

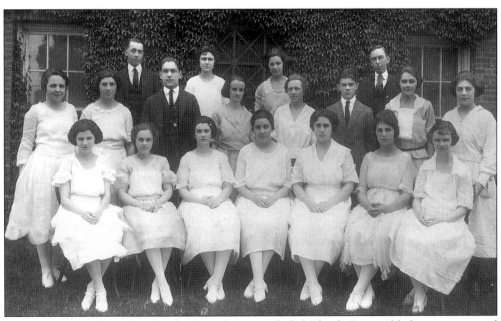

The Mary E. Wells High School Class of 1922 included Thecla Fitzgerald, front center, and Mildred Apte, second row, far right. Fitzgerald went on to teach high school for two generations and retired from Southbridge High School in the mid-1960s. When the new high school on Cole Avenue opened in 1961, Mary E. Wells became the junior high school.

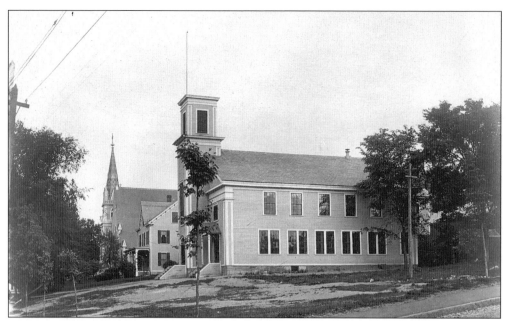

This is a view of St. Mary's School on Hamilton Street at the corner of Pine Street. Beyond is the rectory and St. Mary's Church. The school building, built in 1853, was the first Roman Catholic church in Southbridge, St. Peter's. It was destroyed by fire on Sunday, December 19, 1999. This photograph is undated.

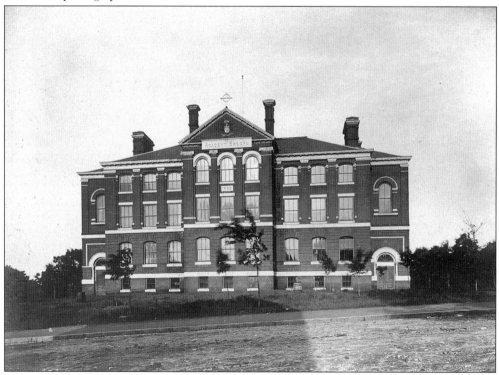

This is the new Brochu Academy (Notre Dame School) on Pine Street. Built in 1899, it could accommodate 550 pupils.

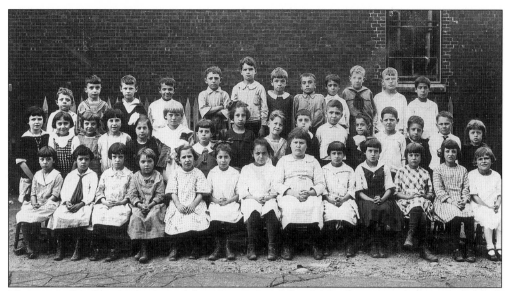

This is another first-grade class of the Main Street School (also known as the Centre School) in September 1922. The students are, from left to right, as follows: (front row) Carrie LaBelle, Lucy Romano (Wielblad), unidentified, Ruth Carpenter, two unidentified, ? Bozzo, and six unidentified; (middle row) eight unidentified, Robert Herron, Robert Savage, Fiore DiMarco, and five unidentified; (back row) Albert Mominee, Raymond Lenti, Bernard Fox, unidentified, John Tobia, four unidentified, Richard Taylor, Joe McKay, and James Righi.

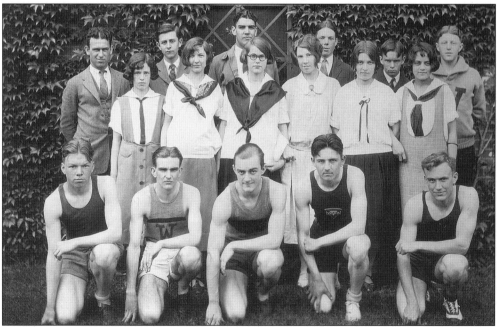

The Mary E. Wells High School track team members c. 1925 are, from left to right, as follows: (front row) Stoughton Litchfield, Richard Tillyer, L.H. Parton, Oscar Duchesneau, and Robert Snell; (middle row) Natalie Morey, Catherine Clarke, Margaret Ohliviler, Marion Horton, Helen Clarke, and Dorothy Pezzetti; (back row) V. Hutchinson (coach), A. Gaucher, D. Fitzgerald, L. Litchfield, Daniel McKinstry, and E. Desautels.

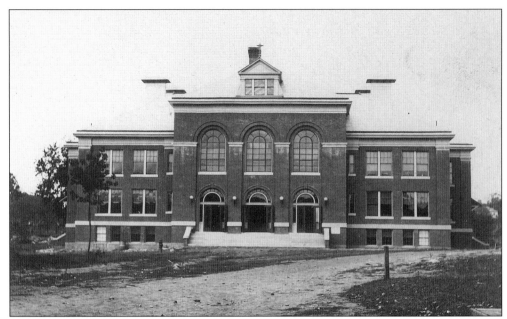

Another parochial school, St. Joan of Arc, was an edifice built by the Sacred Heart parish in 1910 on Brochu Street.

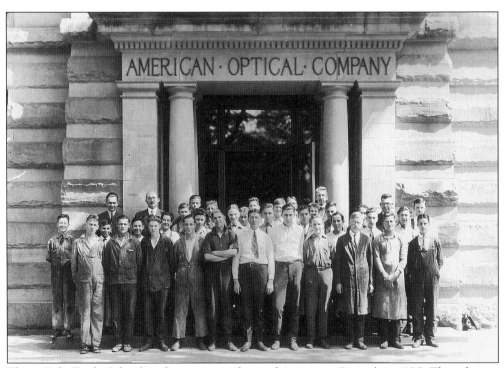

These Cole Trade School students pose in front of American Optical in 1925. Their futures could be behind them.

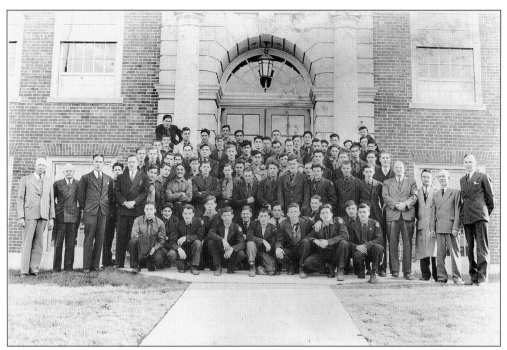

This large group of young men, posed in front of the Cole Trade School, were training for the Civilian Conservation Corps *c.* 1939. Cole Trade, built in 1927, was named for Robert Henry Cole, cofounder of American Optical, and operated until Bay Path Regional Vocational School opened in 1972.

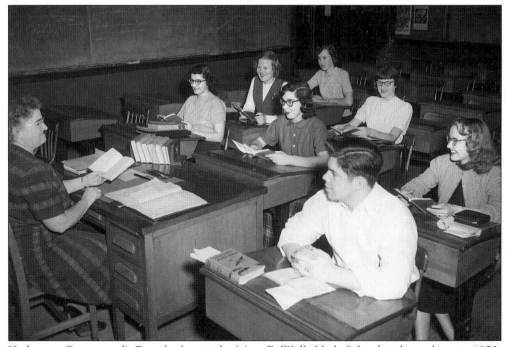

Katheryne Beauregard's French class at the Mary E. Wells High School is shown here in 1950. Her students are unidentified.

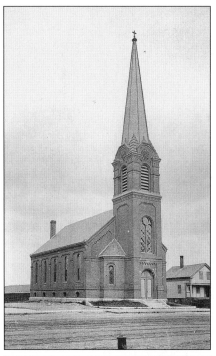

The first religious society to form in what would be Southbridge were the Baptists, organized in 1801. They built their first church in 1848 on Main Street at the corner of Foster Street. That wood building, destroyed in the fire of 1863, is shown in the woodcut, lithograph, and photograph in the first chapter. The new Baptist church, of brick, was built between 1864 and 1866. The official town clock is in the steeple. This photograph was taken at 2:35 p.m. sometime in 1875.

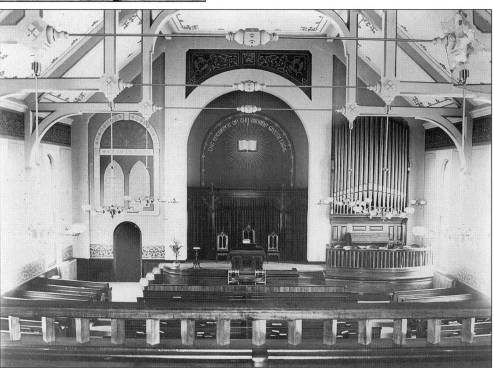

Taken from the choir loft, this pre–World War I view shows the interior of the Baptist church, before alterations were made after 1915. The balcony railing is the same today, but this organ is no longer in front of the congregation, and the decoratively painted rafters are plain wood finish today.

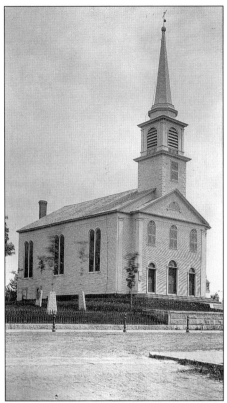

To the right is the first Congregational church, and below is the second, which stands today on Elm Street at the corner of Park Street. The older building was constructed in 1821 and stood until it was severely damaged by a windstorm in the early 1880s. The second church, built of brick, was erected in 1885. Ironically, its steeple was also lost to wind in the Hurricane of 1938. The Congregationalists were also one of the four original denominations organized before 1816. Visible in the lower photograph on the left is part of the old Southbridge Town Hall. Seen on the right is the Samuel Hartwell home, on the other side of Park Street, now Catholic Charities, in this *c.* 1886 photograph.

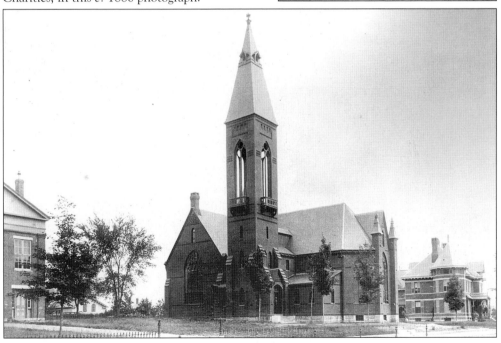

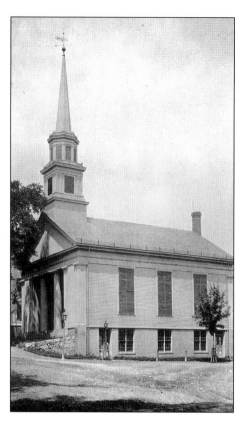

The First Universalist Church of Southbridge (built in 1841) sits at the corner of Main and Hamilton Streets in all of its Greek Revival splendor in 1875. The steeple was blown off the church during the Hurricane of 1938. The society was one of the original religions in what would become the town of Southbridge.

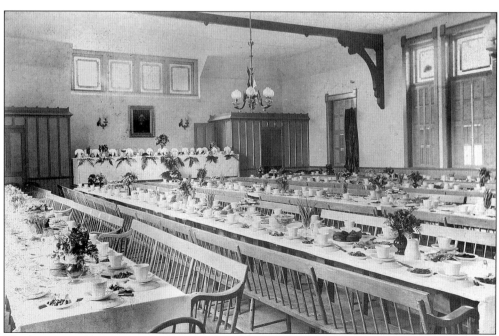

The banquet tables are set this late afternoon for a supper at the Universalist church.

The oldest original church building standing in Southbridge today is United Methodist, on Main Street across from Notre Dame. Built in 1836, it looks much the same today as it does in this 1875 image. The Methodists were one of the four original religious societies.

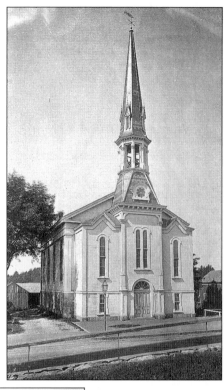

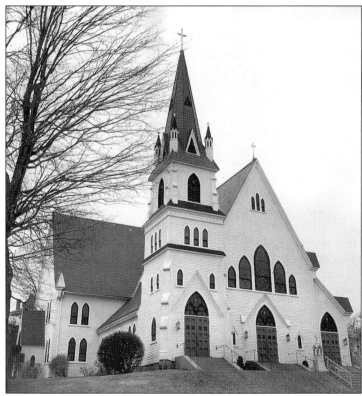

St. Mary's Roman Catholic Church was constructed in the 1870s as a result of the large influx of Catholics into the area during the mid-to-late 1800s. In 1853, St. Peter's Catholic Church had opened and, by 1869, there were over 2,000 parishioners, half of them Irish and half French-Canadian. The parish was then divided. The first Notre Dame was built by the French-Canadians on Pine Street, and St. Mary's was built by the Irish on Hamilton Street.

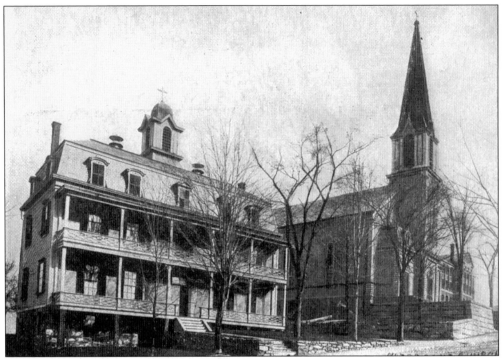

Here in this postcard view we see the whole Notre Dame complex on Pine Street. On the left is the parish home. To the right of the church, near the top of the hill, is the brick parish school building at the corner of Edwards Street (see page 78). The church and parish home are gone. The date of the photograph is unknown.

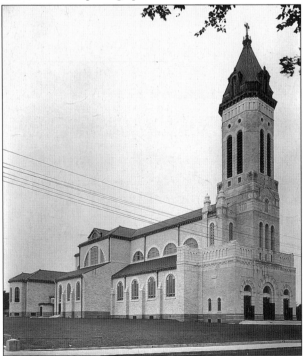

The Notre Dame parish was founded in 1869, and, as mentioned previously, a church building was constructed on Pine Street. That church was replaced by the magnificent Notre Dame Roman Catholic Church, located on Main Street near the corner of Marcy Street. The church was dedicated on July 2, 1916.

This 1875 image shows the Union Church on Hamilton Street. The church was built in 1869 by the Hamilton Woolen Company for the congregation of the Evangelical Free Society. The church disbanded in 1921. It is now known as Holy Trinity Episcopal Church.

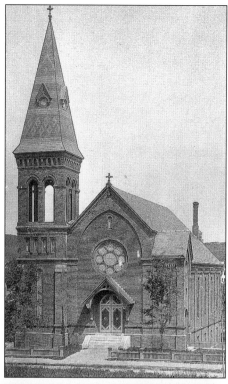

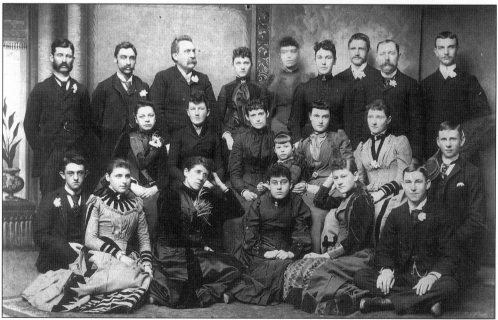

This gathering of the faithful was for the Union Church choir on fast day in 1891. The hungry choir members pictured here are (though not in this order): Mr. and Mrs. Randall, George Smith, Carrie Hill, Horace and Mrs. Carpenter, George Wyman, Jessie Curtis, Mr. Durgin, Blanche Wheeler, Edgar Durgin, Jacobina Taylor, Elmer ?, Bill Taylor, Willis Halstead, Carrie McKee, James Taylor, Lizzie ?, Nellie Stone, May Stellins, and Lillie Hall.

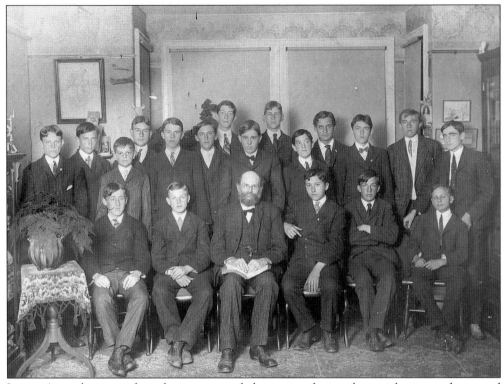

Lucius Ammidown was doing his part to guide his young charges down righteous paths toward upstanding lives, as evidenced in this portrait of his 1905 or 1906 Bible class. From left to right are the following: (front row) Clifford Eaton, Roberts, Mr. Ammidown (teacher and host), Phil Renaud, Charles Cook, and Colin Grant; (back row) Roy Smith, Irving Hall, Phillip Morrill, Jay Lewis, George Lombard, Ernest Hall, Jack Martin, Albert Dansereau, Colburn, Spencer, Martin Jensen, Roy Plimpton, Robert Williams, and Stuart Austin.

The first St. Nicholas Church was built in 1912 on Morris Street. It was the first Albanian Orthodox church constructed in North and South America. The community continued to grow and, by 1941, the current church was built to accommodate the larger congregation.

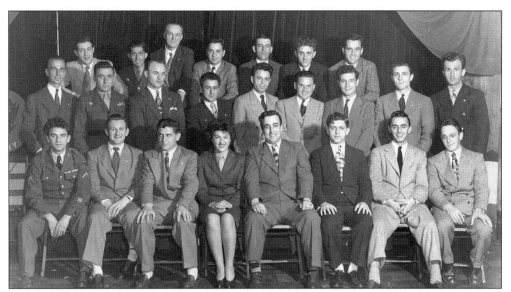

In 1946, St. Nicholas Albanian Orthodox Church held a banquet in honor of the returning Albanian veterans in St. Nicholas Fellowship Hall. From left to right are the following: (front row) Christie Christo, George Vasil, Theodore Michael, Ms. Kontaxi, Dimitri "Shape" Metro, Vangel Costa, Constantine "Cookie" Costa, and Alex Peters; (middle row) Christopher "Keech" Thomas, Steve Ropi, Mitchell Dune, John Peters, Kosta Zotos, Nick Stevens, Kristie Christo, Andrew Petro, and George Prendi; (back row) William Ekonomy, Christie Thomas, Michael Thomas, George Nasse, Alex Theodoss, Lazar Theodoss, and Joseph Theodoss. All the Albanian service people came home safely.

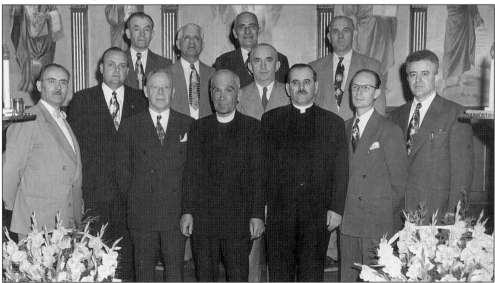

For whatever reason, the new church was not consecrated until October 12, 1952. Gathered on that occasion in this group photograph are parish council members and invited dignitaries. They are, from left to right, as follows: (front row) Dhosi Lazo; Ovide Desrosiers, police chief; Staves, state senator; Bishop Thoefan S. Noli; Thomas Checka; Rev. Llambi Michael; Gabriel Crevier, selectman; and Pandeli Michael; (back row) Ligor Legori; George Costa; Pascal Metro; and James Vasil.

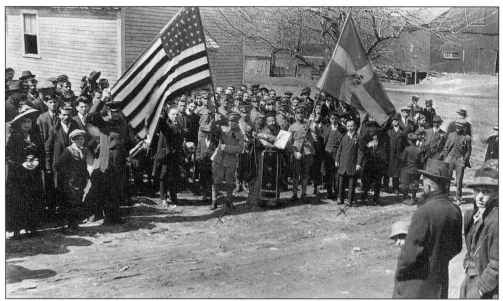

On April 8, 1917, the Sunday after the United States entered World War I, more than 500 people witnessed a flag-raising ceremony that took place near the (first) Greek church on Morris Street (located beyond where the Tradewinds Club house is today). The American flag is being held by James Pantos. Holding the Greek flag is Anastasios Trimpitsikas—father of Helen Zotos. Under the Greek flag is Constantine Pantos—father of Helen Pantos of Worcester. He was instrumental in organizing the Greek community.

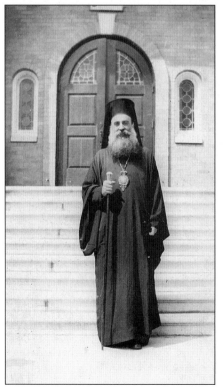

This photograph of the late Ecumenical Patriarch Athenagoras I was taken in August 1935 in front of St. George's Greek Orthodox Church on North Street, when he was archbishop of North and South America. On November 1, 1948, he was elected Ecumenical Patriarch of Constantinople, the highest rank in the Orthodox Church, embracing about 150 million faithful. On January 27, 1949, he was flown to Istanbul on a presidential plane provided by President Truman to accept the ecumenical throne.

Some founders of St. Michael's Romanian Orthodox Church are seen here in 1924. Pictured, from left to right, are the following: (front row) Fr. Martin Jonesco and Christa Demma; (back row) Vasile Topi and Stavri Zhamo.

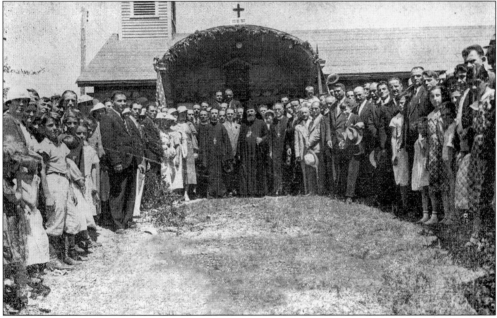

Standing in front of the first St. Michael's Church off Cisco Street in August 1935, the parishioners formed a horseshoe pattern in order to fit in the picture. In the center is Bishop Policarp. The large congregation outgrew the first church and, in 1960, the second church was built and dedicated on this site.

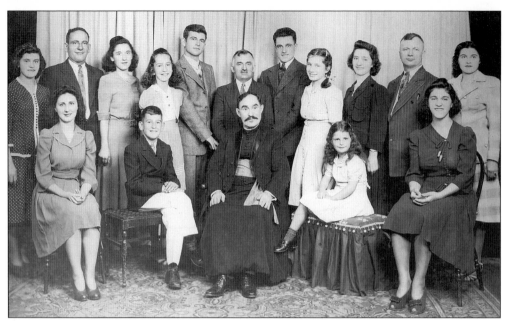

Pictured here is the St. Michael's Church choir in 1942. From left to right are the following: (front row) Athena Yanka, Stavry Ziu, Father Petrovich, Helene Topi, and Mary Vanghel; (back row) Paulina Nasto, Thoma Ziu, Domenica Ziu, L. Ziu, Vanghel Bombi, Rapo Nasto, Kliu Yanka, Olympia Apostola, Alexandre Yanka, Petrea Belba, and Doxa Yanka.

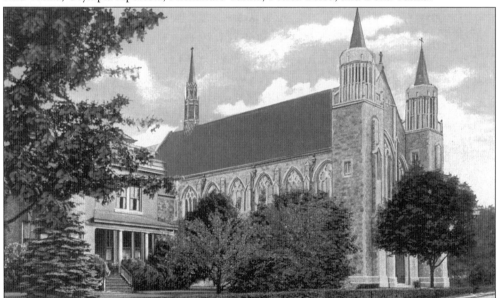

L'Eglise de Sacre Coeur (Sacred Heart Church), on Charlton Street, was another Catholic church. It was founded in November 1908 to serve the French population, which had become too large for one parish—Notre Dame. The rectory, on the left, originally served as a church-school combination. In 1925, Fr. Victor Epinard became pastor and is credited with the existence of this beautiful church with its fine red slate roof. St. Hedwig's Church on Everett Street, which has long been the Polish parish, is the other of four Roman Catholic parishes in Southbridge.

Four

Everyday Life

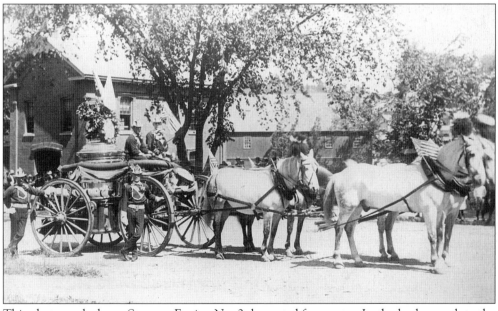

This photograph shows Steamer Engine No. 2 decorated for muster. In the background, to the left, is the old No. 2 Engine House, located on the north side of Main Street in the Globe Village part of Southbridge, immediately east of the Main Street bridge over the Quinebaug River. The old No. 2 Engine House was replaced by a three-bay firehouse on West Street in 1894. Behind the engine house are the carpenter shops of the Hamilton Woolen Company (see page 39). None of the buildings in this 1880s photograph remain today.

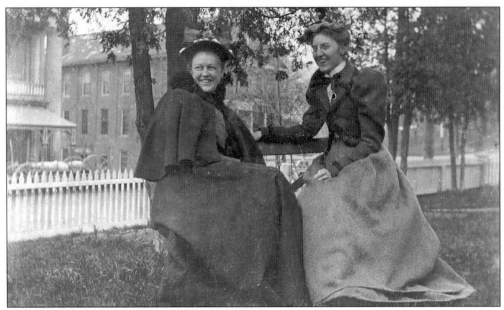

One afternoon *c.* 1890, Elizabeth Booth (Clarke) and Annie Sharp (Sutcliff) enjoyed each other's company in this yard at the foot of High Street in Globe Village. Today, a gas station and convenience store occupy this site. In the background, on the left, part of Gothic Hall can be seen. This building, on the west corner of Mill Street, stands today. At one time, four massive columns graced the front of this building. Visible on the east side of Mill Street is the side of the Union Block, which was later known as the Laughnane Building. It burned in the 1970s.

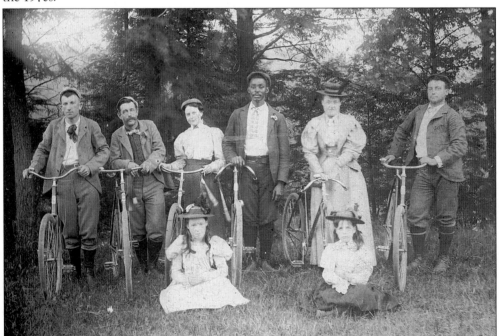

In 1897, there was an organization known as the Sandersdale Bicycle Club. This group of eight is posed with six bikes. Maybe the two ladies in front rode on two of the gentlemen's handlebars.

In c. 1900, Mr. and Mrs. Bibeau took their son George, born in 1896, to the LaBonte Studio at 2 Chapin Street to have a portrait made. The fashion for young boys at that time was flouncy collars, cuffs, bows, and banana curls. He was the father of Doris Hopkins.

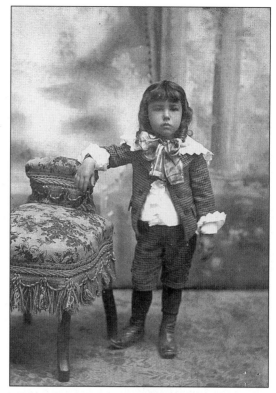

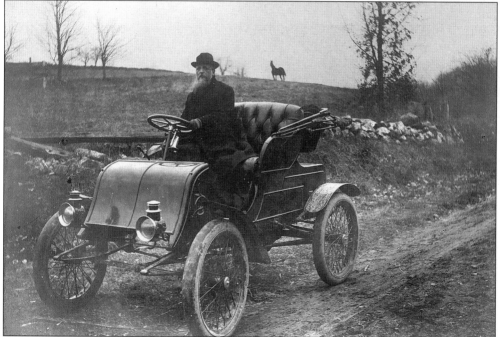

Alfred E. Cole paused long enough for this photograph to be taken in his automobile on a lane in Southbridge. His father, Robert H. Cole, was one of the pioneers of Southbridge's optical industry.

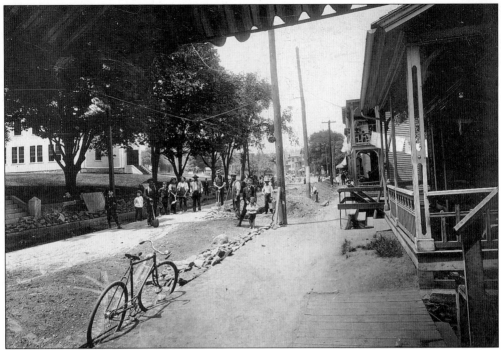

We are on Hamilton Street across from St. Mary's rectory on this summer day. The laborers have taken a break from their ditch digging. Some of the men are standing in the trolley tracks. The power line for the cars can be seen overhead. As usual, several boys are watching the activity in this *c.* 1900 photograph.

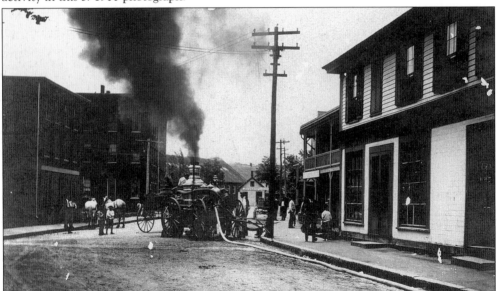

Engine No. 2 is shown at work on Pleasant Street, but we will never know what was afire in this undated photograph. The pumper (see page 93) is belching black smoke, and a fire hose runs along the gutter. The large brick building in the background is the Alden Block at the corner of Pleasant and West Main Streets, the location of J.J. Delehanty's Furniture Store for over 125 years. Again, in the picture, curious boys are looking on.

Westville is seen here in February 1888. This view is looking east on (Old) South Street, which ran along the Quinebaug River in Westville (now part of the Westville recreational area). In the center is the blacksmith's shop, complete with an outhouse overhanging the river. Beyond the blacksmith's shop is an old Westville landmark, the Leaning Pine. This grand old pine tree was cut down in the 1950s. The hill rising in the background is Dennison Hill, devoid of trees.

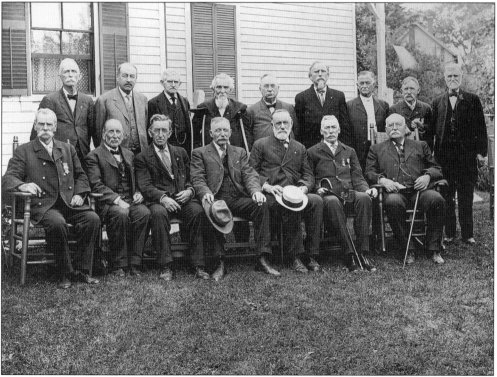

Shown in this view are the Grand Army of the Republic veterans of Southbridge. Out of a population of 3,677 at the time of the Civil War, Southbridge supplied 400 men.

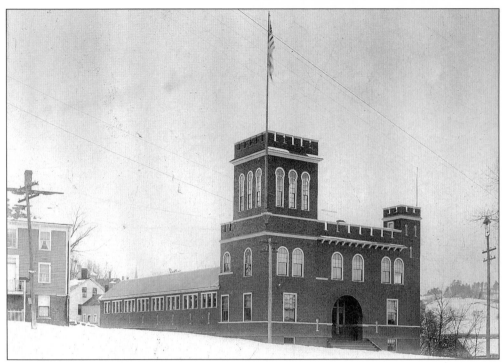

Southbridge's first armory, at the corner of Central and Hook Streets, was built in 1897. Later, the armory was relocated to Goddard Street, during the mid-1900s. Today's armory, off Morris Street, was built in the 1960s. The 1897 building became the home of the California Fruit Company, a wholesale distributor, for many years during the mid-to-late 20th century. The building stands today, although its appearance is much changed.

Eli Rheaume (left) and two unidentified gentlemen pose at the Warner Studio, 108 Hamilton Street, in matching topcoats and derby hats c. 1900. Rheaume was an optician and was sent to Atlanta by American Optical to sell glasses town-to-town throughout Georgia. At some point, he married an older woman in Atlanta. She died, and he inherited a whole city block on Peachtree Street, according to his niece Doris Hopkins.

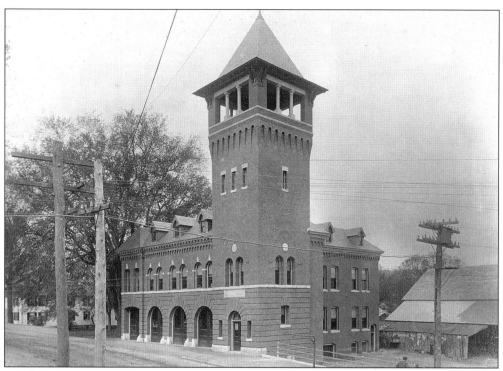

Familiar to everyone from Southbridge, the fire station, built in 1899 as No. 1 Engine House, is the fourth and final station built in town (see page 19). It is on Elm Street on the site of Freeman's Tavern. The great elm tree, visible beside the building, lived for another 60 years (see pages 104 and 105). The building was new in this c. 1900 view.

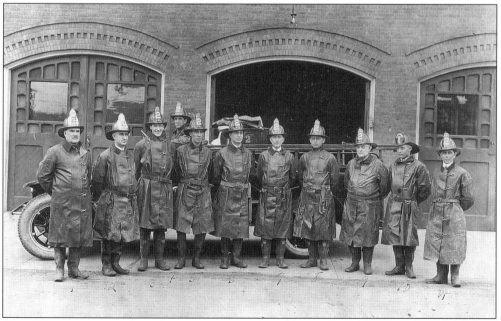

This 1920s photograph shows firefighters of the Engine No. 2 Firehouse, built in 1894 on West Street. The building still stands today.

Young Ulric Brault was once the New England Wrestling Champion before he became chief of police in 1920. The date of this photograph is unknown. However, standing behind Brault are two St. Martins and, on the right, Durocher (the priest's father), according to the back of the image.

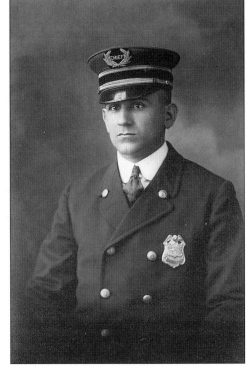

Shown here is Southbridge police chief Ulric Brault, who held that position from 1920 to 1950. He was the uncle of Armand Brault, Emile Brault, Laurette (Brault) Houde, Simone (Brault) Robida, and Juliette (Brault) McGrath.

Somewhere in Southbridge, possibly Gibraltar Field in the "Flat," are immigrant Andrew Lenti and an unidentified driver. Shortly after this photograph was taken (*c.* 1920), Lenti returned to Italy to stay. His sons Frank and Umberto came to the United States later and settled in town.

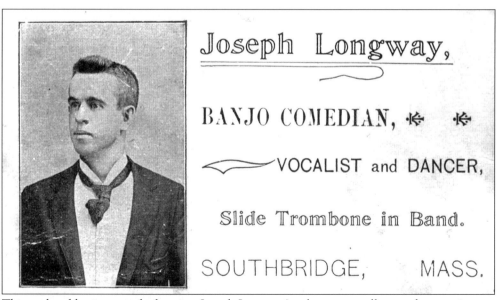

This undated business card advertises Joseph Longway's talents as an all-around entertainer.

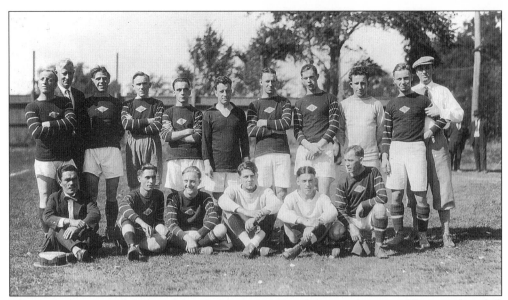

The American Optical Company soccer team of 1921 is shown in this view. They are, from left to right, as follows: (front row) Mr. Salviuolo (assistant manager), Mr. Sutherland, Mr. Yates, Eric White, Mr. Martel, and John Young; (back row) James Young, William Hooper (manager), Mr. Torrence, Mr. Ferguson, Joe Reid, Harry Haynes, Mr. Ackrey, M. Hooper, Mr. Larochelle, Otto Boerner, and Seaver Rice.

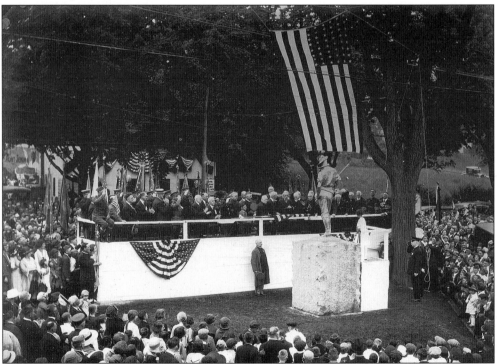

Shown here is the dedication of the Spanish-American War monument on July 4, 1923. This monument is located at the intersection of Hook and Hamilton Streets and is known as the Hiker Monument.

Louis Bibeau poses in his substantial and productive garden on Henry Street probably in the late 1920s. The plot was to the rear of his home at 53 Worcester Street. It looks like he grew lots of beans on the perimeter fence. The leafy patch in the middle of his plot is broad-leaf tobacco. He sold the excess harvest to neighbors. It may have been Sunday. Bibeau has on a necktie and straw boater, and two women seem to be at leisure in the first-floor and third-floor porches of 18 Henry Street. Bibeau was the grandfather of Doris Hopkins.

Sitting at the wheel of the family car, a Peerless, behind the home at 19 Plimpton Street, is Elodia Rheaume Bibeau in the late 1920s. The Bibeaus kept that car until c. 1940, according to daughter Doris Hopkins.

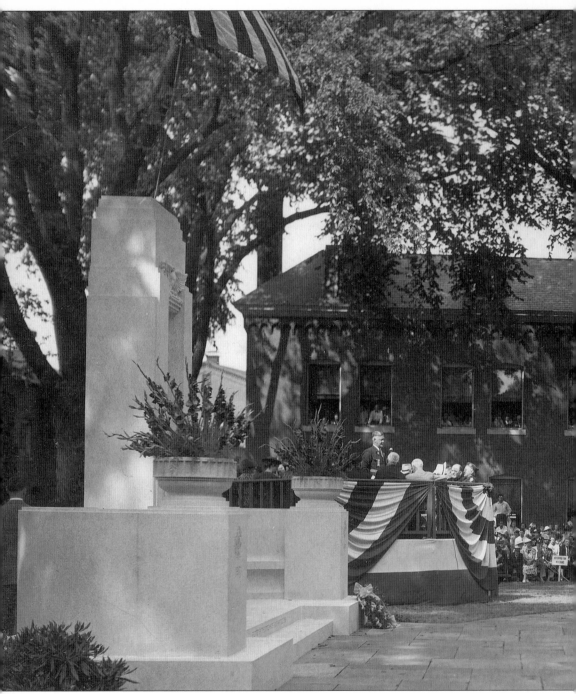

On Saturday, August 27, 1938, the World War (I) Memorial Park on Elm Street was dedicated. Speaking to the audience is Gov. Charles F. Hurley. Also in attendance was Hon. Henry Cabot Lodge. This was an all-day affair beginning with a military and civic parade at 10:00 a.m. and then the ceremonies with a flag raising by Gold Star mother Marie Louis Donais and reveille by the 13th Infantry Band, an invocation, "America" by the band, and the unveiling of the monument by Joan Hill and Master Charles Peloquin. Presentation and acceptance were

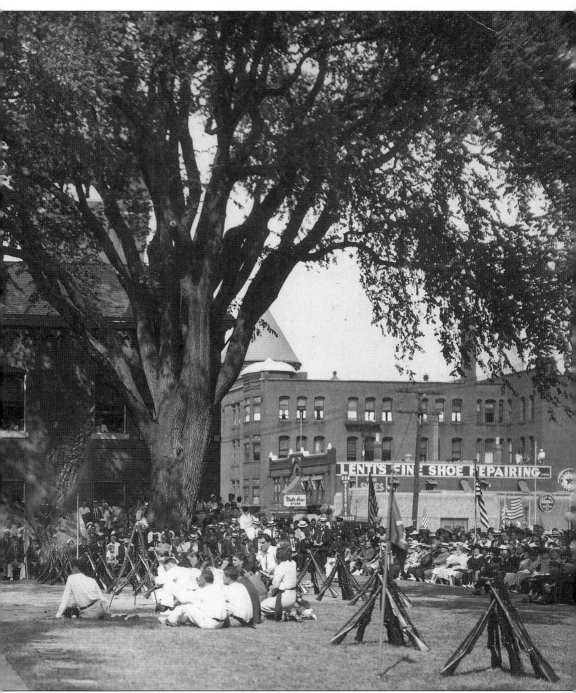

followed by dignitaries' speeches, the reading of the Honor Roll, taps by Wilfred Girard, and "Benediction" and "The Star-Spangled Banner" by the 13th Infantry Band. The flag was lowered at 7:00 p.m., and the dedication dance in the Southbridge Town Hall began at 8:00 p.m. Mrs. Freeman, grandmother of Luther Ammidown, planted "the Big Elm" pride of Southbridge in 1765. This venerable tree survived hurricanes and the ravages of Dutch elm disease. It was cut down to make way for the firehouse addition in 1959.

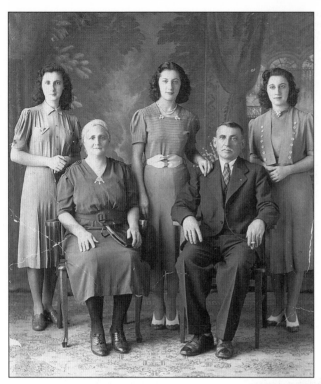

In 1937, the Malisory family of Southbridge sat for this portrait. Nicola arrived here by c. 1918 and Maria by 1920. Both of Romanian descent, they were actually born in Albania. From left to right are Athena (Yanka), mother Maria, Helen (Thomo), father Nicola, and Olga (Seferi). All three Malisory daughters were born here.

Posing proudly and looking dapper in his Strand Theatre usher's uniform is 18-year-old Ernest Tsoules in 1937. Two other workers at that time were Bernie Fox and Tom "Cash" Carey.

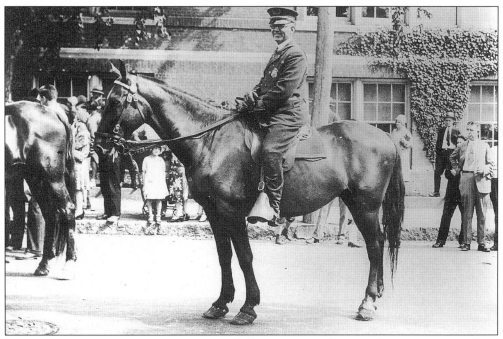

Chief Brault is in a parade c. 1930 passing by Wells High School. He was a well-loved town official for 30 years and was known for riding horses.

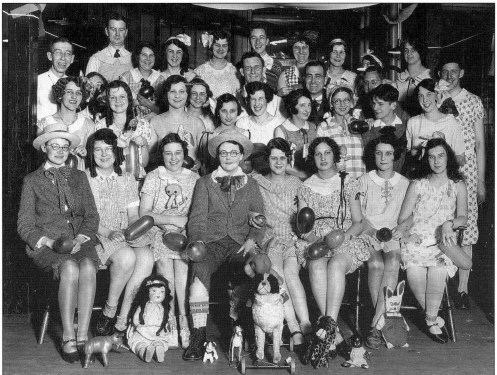

Revelers at a Christmas party held at American Optical are seen here c. 1940. These folks really look like they are having a good time.

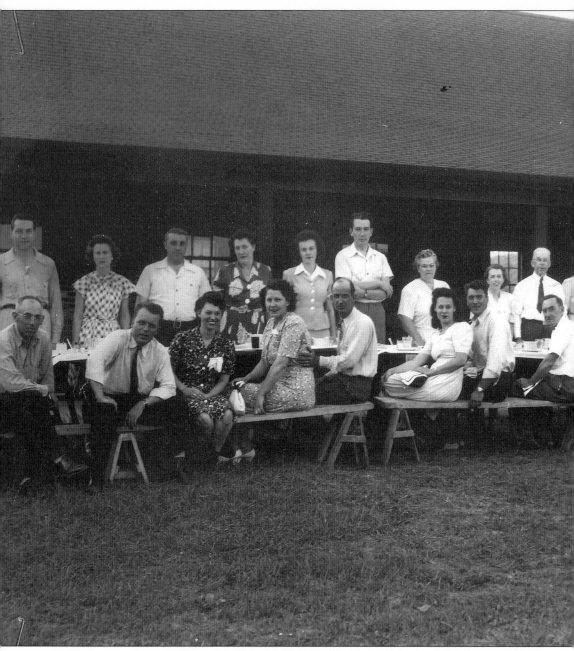

The Worcester Street Railway (Southbridge Division) held its outing, a clambake, on July 18, 1946, at the Hamilton Rod and Gun Club in Sturbridge. By this time, buses had replaced streetcars. From left to right are the following: Mr. Ashton, Francis Splaine, Yvonne (Lescarbeau) Splaine, Germaine (Donais) Gravel, Harold Gravel, Edna (Rainbow) Bachand, Lionel "Coke" Bachand, Bill McCann, Mr. and Mrs. Norcross (from Charlton), sister of McQuade, Eddie McQuade, Mrs. McQuade, Lionel Gagnon, Mrs. Gagnon, unidentified, Victor

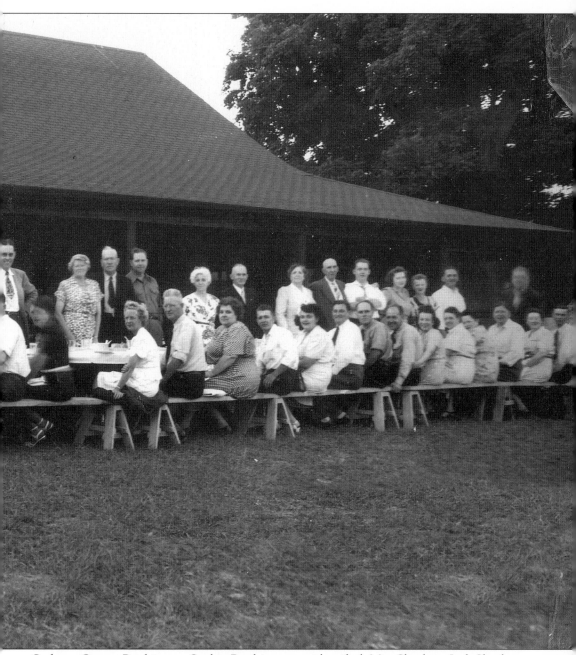

Coderre, George Berthiaume, Sophie Berthiaume, unidentified, May Sheehan, Jack Sheehan, Ola (Lamarine) Splaine, and James Splaine; (back row) unidentified, unidentified, Roland St. Martin, Mrs. ? (Alexander) St. Martin, Mrs. ? (Lorange) Dunleavy, John Dunleavy, unidentified, Burns's daughter, Mr. Burns, Mrs. Murphy, Mr. Murphy (from Worcester), Mr. Bennett, Mrs. Bennett, the Bennetts' son, and the rest unidentified.

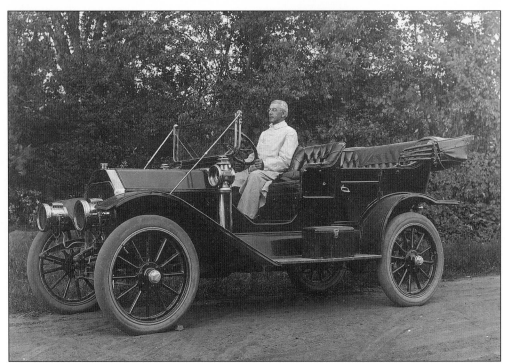

Sitting at the wheel of this magnificent horseless carriage is J. Ouimette. Under the left front wheel is a chock block. The car is thought to be an Oakland or a Thomas Flyer.

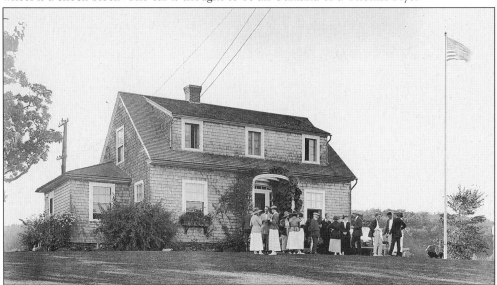

It was *c.* 1920 when this well-heeled group gathered outside the clubhouse on the grounds of Cohasse Country Club. The club was conceived by Channing, Albert, and J. Cheney Wells in 1916, and they started work right after famed golf course authority Donald J. Ross viewed the Cohasse Farm and found it an excellent site. It opened in July 1918 with six holes, overseen by Channing Wells (president), E. Benjamin Armstrong (vice president), and Raymond M. Burnham (treasurer). The first links in Southbridge existed in the North Woodstock Road and Golf Street neighborhood from August 16, 1900, until 1911.

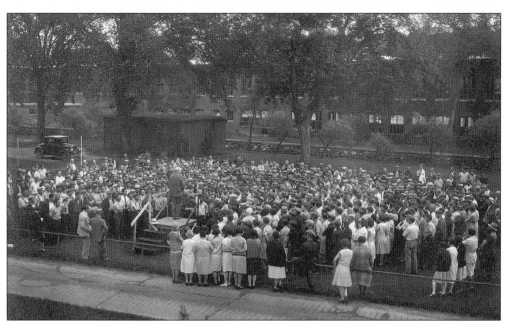

President of American Optical Albert B. Wells is shown here urging American Optical workers to donate to the Harrington Hospital Drive. This photograph was taken on June 17, 1930.

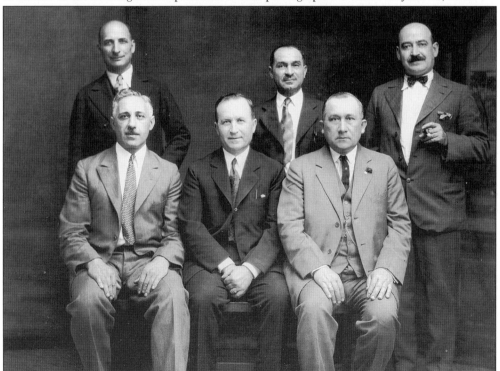

The Italian community and other ethnic groups were asked to support the construction of Harrington Memorial Hospital by raising money for the cause. Shown here in 1929 or 1930 are, from left to right, the following: (front row) John Soldani, David Lenti, and Luigi Salce; (back row) Fileno DiGregorio, John Volpini, and Joe Fiorelli, representing the Italians.

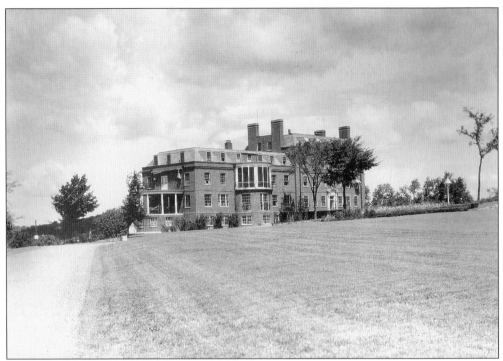

This is a 1931 photograph of Harrington Memorial Hospital, located at 100 South Street. Many additions have been made to the hospital since it opened in 1931. The hospital opened due to the contributions of Charles Harrington and additional contributions made by the people of Southbridge.

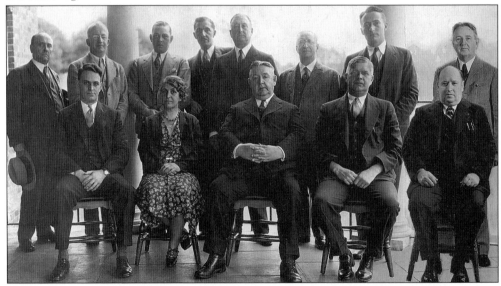

Pictured here is the active medical staff of 1932 for Harrington Memorial Hospital. The doctors are, from left to right, as follows: (front row) Stewart M. Gibson, Adah B. Eccleston, George Webster, Alvin R. Moses, and George W. Tully; (back row) Joseph Page, Theodore L. Story, Marshall Calcord, William E. Langevin, Charles Simpson, Joseph E. Donais, James T. Lacy, and Albert J. McCrea.

Were these ladies waiting for the men to shut down the steam-powered sawmill for the day—or just watching—on this November 2, 1913? The mill was located behind Hamilton Woolen Company's Big Pond on West Street. This area was called Ten Acre and eventually became the Westwood Hills neighborhood.

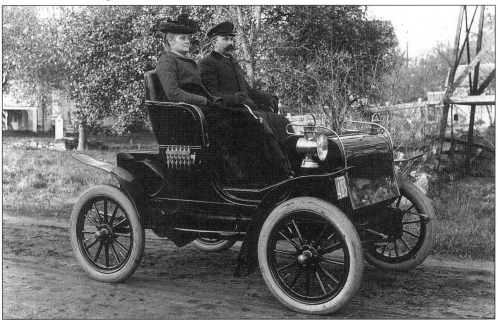

Nelson Baker (see page 51) and his wife are shown c. 1908. Research for this book has suggested he may have had the first horseless carriage in town. The make of the car is said to be a Stevens-Duryea. Baker was an executive at American Optical and an automobile enthusiast from the start, as evidenced by other photographs and references. J. Ouimette (see page 110) may have been sitting in a later car of Mr. Baker.

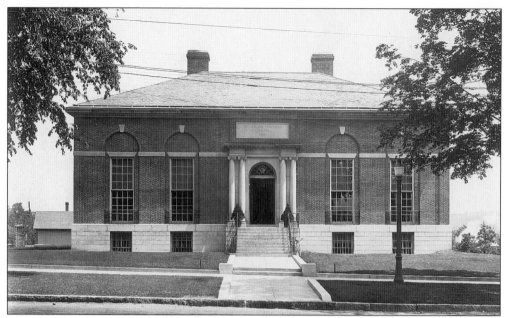

This is a 1915 view of the Jacob Edwards Memorial Library, located on Main Street. The library is named after Jacob Edwards, a successful merchant and manufacturer who was born on December 15, 1815, in what was then the poll parish of Southbridge. He died in Boston in 1902. Edwards gave the town no less than $50,000 to build this wonderful library. Unfortunately, he did not live to see it. The library was constructed and opened for use in 1915.

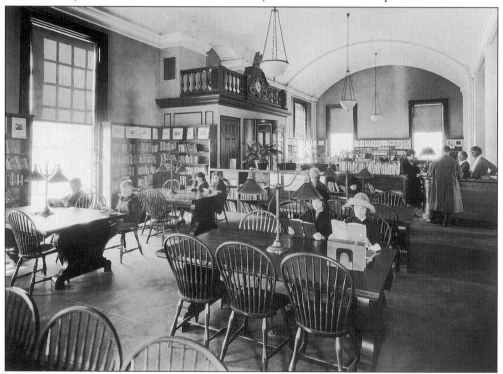

This *c.* 1920 photograph shows the reading room of the Jacob Edwards Memorial Library.

Five

HOUSES, FARMS, AND CELEBRATIONS

The first dwelling in Southbridge was the "famous" Deneson Rock. When James Deneson was awarded his lot in a drawing of the Massachusetts General Court in July 1730, he worked his way here, through wilderness, to find this natural shelter on a slope just south of the Quinebaug River. He stayed. His daughter Experience was the first white child born here (on August 31, 1732). She lies buried in Sturbridge Center Cemetery. The first school was in his barn. He was elected 17 times as selectman. In 1901, the Quinebaug Historical Society (of Southbridge) had "Deneson Rock" etched onto this erratic boulder. Over the years, the spelling of Deneson has evolved into Dennison, as in Dennison Drive and Dennison Hill.

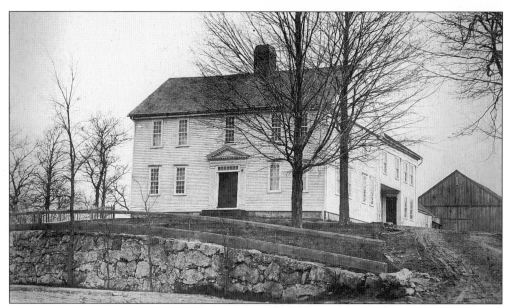

A few years after he began his mill operations, Moses Marcy built this handsome home in *c.* 1738. According to Quinebaug Historical Society leaflets, it was the first "upright" house in what would be Southbridge. During the Revolution, "a company of militia sent to assist in the capture of Benedict Arnold, were entertained at dinner, in this house." Later, in 1786, Moses's grandson William Learned Marcy was born here, considered Southbridge's most famous son. The house stood at the corner of Main and Marcy Streets and was demolished to make way for the new Notre Dame in the early 1900s.

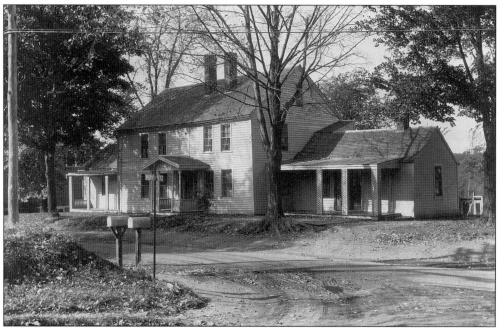

This is a 1920 view of the Newell House, located at the intersection of South and Water Streets. This house, which is still standing, dates back to 1742 and is possibly the oldest house in Southbridge.

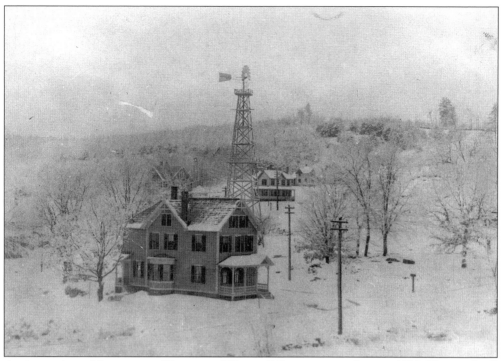

A winter view of the corner of Spring and Hartwell Streets is seen here c. 1900. The windmill was used to pump water to a small cement-lined reservoir on a hill off of Prospect Street. The water then flowed by gravity to the Hillside Park Houses, an 1890s development.

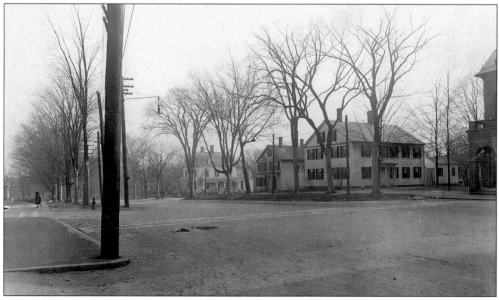

In 1907, the Southbridge Post Office of today did not exist. Two homes occupied the site. From left to right are the Calvin D. Paige House (today's Southbridge Credit Union) and the homes of Mrs. M.E. Beecher and Mrs. L.S. Ammidown (on the site of the Southbridge Post Office). Part of the Southbridge Savings Bank is on the right. This view is from the north side of Main Street, from the beginning of the old Centre School/police station driveway.

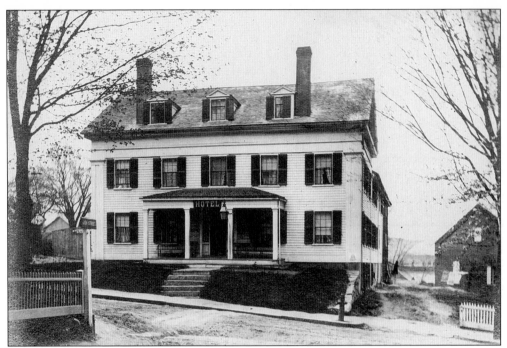

Globe Village was a destination unto itself, as this photograph of the Globe Hotel on High Street suggests. It was taken from Ash Street sometime after 1880. The clue to the date is the fireplug. The water company was founded in 1880.

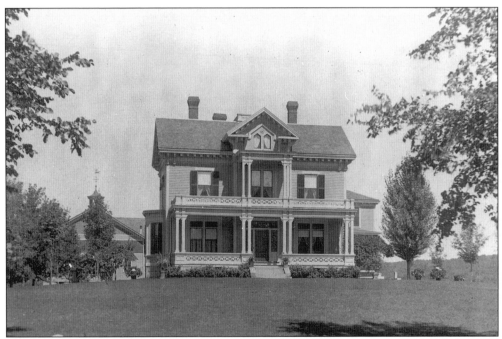

This is a 1901 photograph of the home of George Washington Wells. Wells was one of the founders of the American Optical Company. This house was located on Main Street at the current site of Dresser Park. The house dates to the mid-19th century.

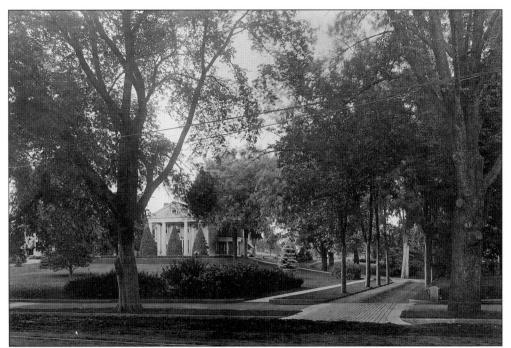

Shown c. 1920 is the front of the Channing M. Wells home, located at 155 Main Street. This house was built by Moses Plimpton sometime prior to 1844 and is now owned and used by the Southbridge chapter of the BPO Elks Club.

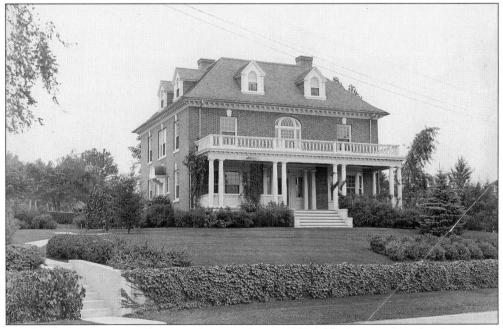

Known as the Charles D. Harrington House, this stately brick home stood on South Street, at the corner of Oakes Avenue, until it was razed c. 1960. It was built by Julius Dresser, an American Optical employee, and was later sold to Harrington. A fine brick wall in front and the old carriage house in the back remains today. The date of the photograph is unknown.

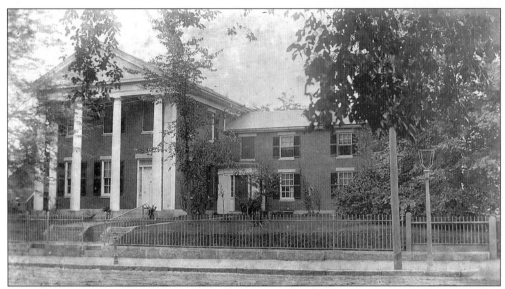

The Tiffany-Leonard House, at 25 Elm Street, is shown here as it appeared in 1891. Bela Tiffany built this house in 1832. He was originally from South Brimfield (now Wales). He had been in business with Samuel Slater in Webster. Tiffany retired to Southbridge and built this brick house. Tiffany was prominent in town affairs until his death in 1851. After his death, Manning Leonard (see page 43) purchased the house. It now serves as the offices of the Southbridge Evening News.

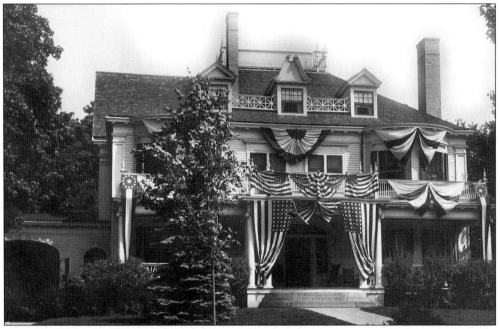

Most of this home at 39 Elm Street remains and is accessible. It is the Elm Center Building, before the commercial brick front was added in the early 1960s. Known as the John Paige residence, it housed the office of Dr. Nerio Pioppi for many years. The elegant front doorway with fan window and sidelights was preserved and installed at the old Sturbridge Fairgrounds building, now Piccadilly Pub, where it can be seen and admired.

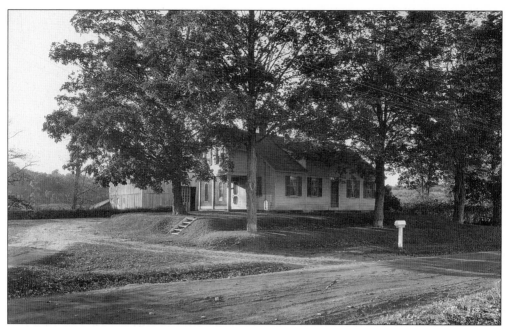

"To Leonard Edwards who has faithfully worked on this farm over thirty years" reads the inscription on this house portrait of the McKinstry Farm at 361 Pleasant Street before renovation in the 1940s. Their farm operations were mostly in the northwest part of town. Just over the hill east of McKinstry's was the Clemence family's farm on Clemence Hill Road.

This photograph shows an interior view of the McKinstry Farm. The date of these two images by R.M. Litchfield Photography of Southbridge is unknown, but the house has electricity by this time.

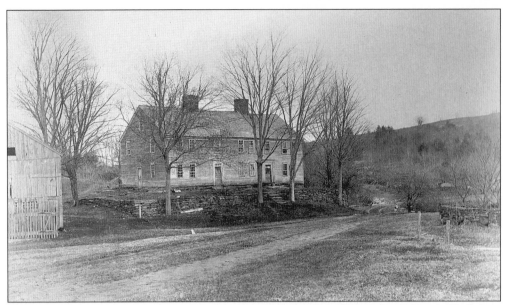

This very early "duplex" may have been the "Haskell place" on Tipton Rock Road. The house may have been abandoned by the time of this photograph (the date unknown). It has been said that a horrific, tragic crime occurred near here a very long time ago. It does seem to have a sinister aura. This section of Tipton Rock Road is actually named Crops Road. The Morse neighborhood cemetery is located near here, just east of North Woodstock Road.

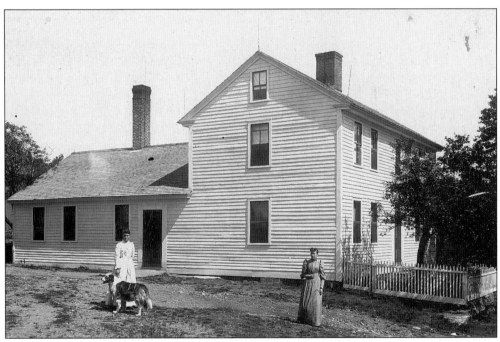

It was summer in 1894 when this photograph was taken of Harrison Harwood's Farm at Breakneck. It stood on Breakneck Road opposite today's fifth reservoir dam. The two women are unidentified. Much of the former Harwood property is part of the Southbridge Water Supply Company's watershed today.

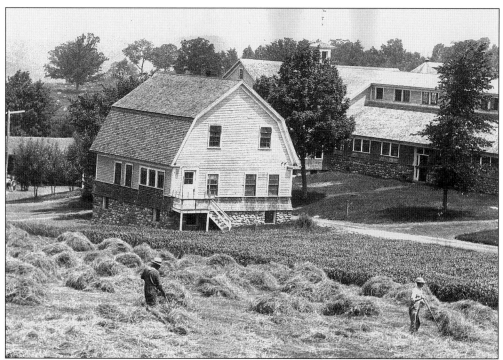

The Herman Cheney farm was on North Woodstock Road. Built *c.* 1900, it was a "gentleman's farm." In this haying scene, we see the gambrel barn where bottling took place. In the mid-1900s, it was moved about 200 feet down the road and converted into a house now 430 North Woodstock Road.

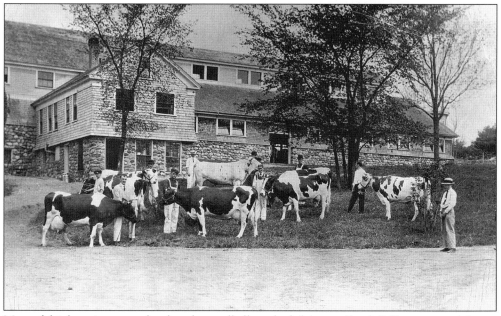

Most of this barn is gone today, but the small ell on the left is now Frank DiBonaventura's home at 440 North Woodstock Road. The lower level of the main barn was the milking room. This photograph was taken *c.* 1920. No one in these views of the Cheney farm is identified.

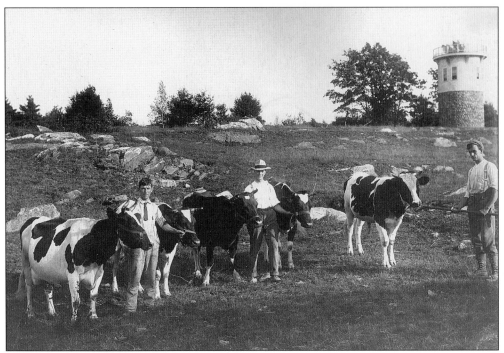

Some of the help at the Cheney farm washed and dressed up for this portrait. (Or was it Sunday?) In the background is the farm water tank with observation deck, still standing today.

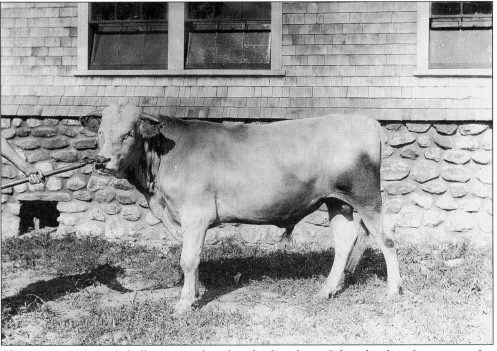

Cheney's prizewinning bull was sought after for breeding. Other families farming in this southeast part of town were the Morses, Pratts, and Shermans. Toward the late 1940s, Southbridge still had 10 farms.

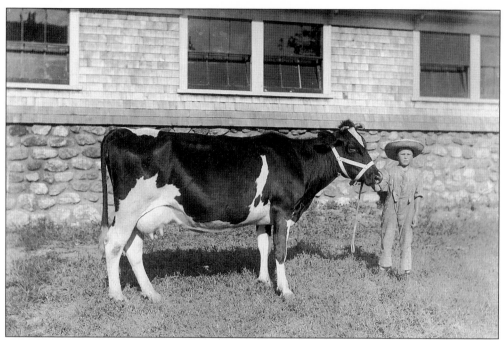

This view shows a boy with his cow. Aaron Pease, a Southbridge photographer, took these photographs of the Cheney farm very early in the 20th century. Histories of Southbridge claim that we had better farms than Sturbridge or Charlton, due to better soil. However, the town's industrial economy gradually overtook agriculture, and farming operations dwindled away.

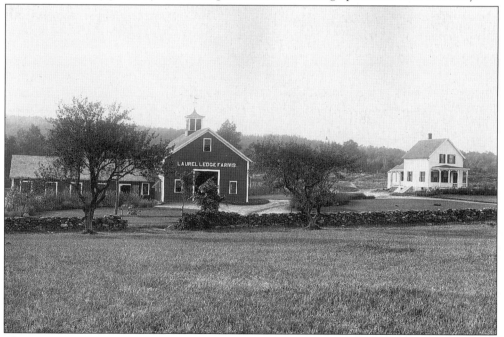

This quaint and well-kept little farm is 281 North Woodstock Road today. The barn was destroyed by fire on Christmas Day, so many years ago that no one interviewed for this book could remember it.

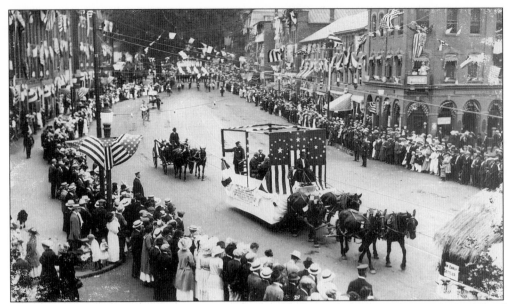

Southbridge celebrated its centennial during Independence Day week in 1916. All of downtown and many homes and businesses were decked out with bunting, flags, and banners. The celebration climaxed on July 4 with a huge parade, of which many photographs exist. Shown here is one of many horse-drawn floats as viewed from upstairs in the YMCA.

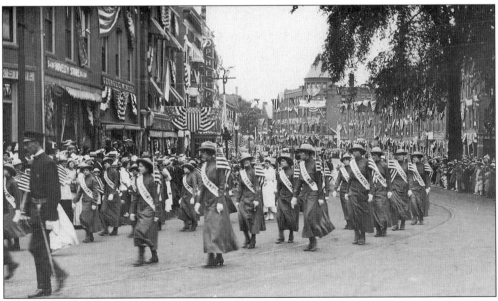

These women in uniform and marching in formation were probably some sort of auxiliary organization in support of the military or the American Red Cross. In another photograph, they are posed on the Southbridge Town Hall steps with Uncle Sam and some young girls in Red Cross outfits. Dressed in white in the center of the photograph is Elodia Rheaume, mother of Doris Hopkins, as the group turns into Hamilton Street.

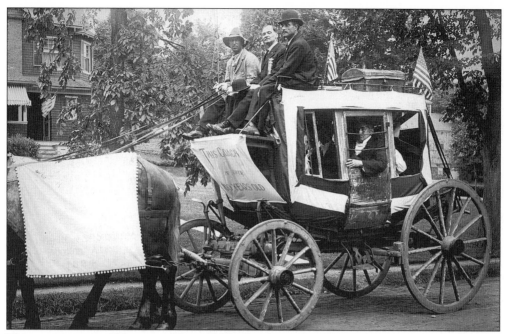

This carriage was 100 years old in 1916 when it took part in the Town of Southbridge Centennial Parade. No wonder the rider in the carriage is looking nervous.

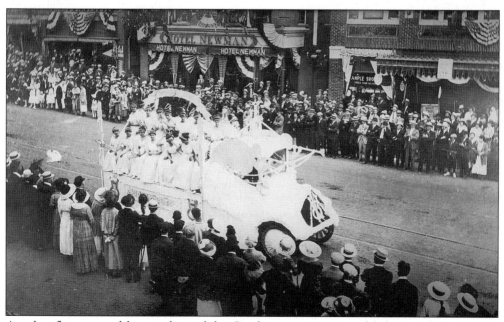

Another float entered by members of the Greek community carried ladies in classic ancient Grecian costumes. Right after them came a group of men in Greek military uniform.

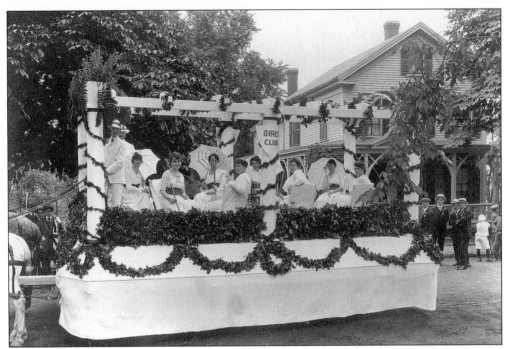

There are a number of images of the Southbridge Girls Club float. They rode in comfort and style in their rolling arbor.

Several years later, after World War I, Southbridge held another parade. This entry from the Sons of Italy depicts a battle scene in the Italian Alps. One of these "soldiers" is Frank Sinni.